GUILDFORD PUBS

DAVID ROSE

AMBERLEY

First published 2016

Amberley Publishing
The Hill, Stroud
Gloucestershire, GL5 4EP

www.amberley-books.com

Copyright © David Rose, 2016
Maps contain Ordnance Survey data.
Crown Copyright and database right, 2016

The right of David Rose to be identified as
the Author of this work has been asserted in
accordance with the Copyrights, Designs and
Patents Act 1988.

ISBN 978 1 4456 5719 6 (print)
ISBN 978 1 4456 5720 2 (ebook)

British Library Cataloguing in Publication Data.
A catalogue record for this book is available from
the British Library.

Origination by Amberley Publishing.
Printed in the UK.

Contents

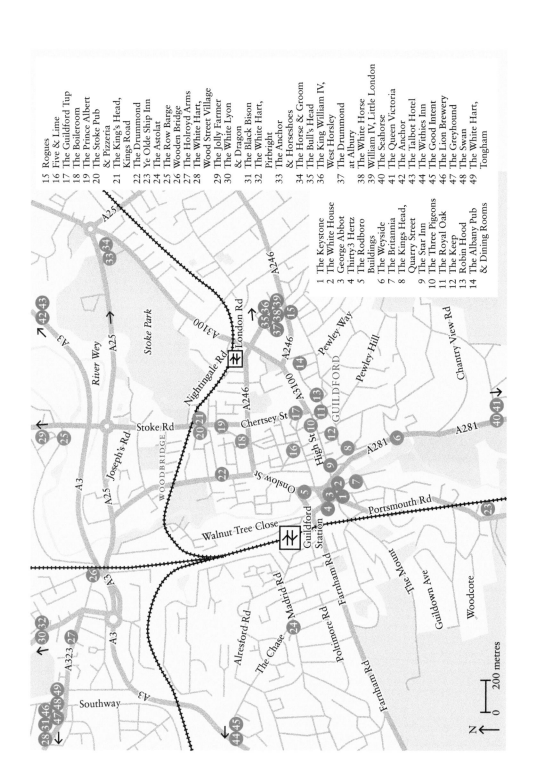

Introduction

Guildford has a long and interesting history, and all the while people have inhabited the town they have probably enjoyed a tipple or two.

In Saxon times the town was very small – likely to have been a small cluster of buildings on either side of today's High Street. Through the centuries it grew, albeit very slowly, and became a market town for the west Surrey area. Back then brewing of ale was often done in people's own homes, but, in common with other towns and cities, Guildford appears to have had some inns, taverns and alehouses.

Surviving court record books from the sixteenth century reveal that Guildford employed 'ale tasters', whose job it was to taste and assize beer that was offered for sale and report back to the corporation's mayor and approved men. The corporation would impose conditions on keepers of alehouses and taverns, such as forcing them to have suitable signboards on their premises and close down premises that were deemed unsatisfactory.

The Wey Navigation waterway, from the Thames at Weybridge to Guildford, opened in 1653. It allowed the transportation of goods and gave the town a boost to its increasing prosperity. In time, highways were also improved and Guildford became an important staging post on the turnpike road from London to Portsmouth.

Coaching inns came into being, such as the Crown, the White Hart, the Red Lion and the Angel – with only the latter still in existence as a hotel and restaurant today. The diarist Samuel Pepys wrote about visits to Guildford and it appears he particularly favoured the Red Lion, which stood in the High Street on the corner with Market Street. His diary from 4 May 1660 states, '… and so to Gilford, where we lay at the Red Lyon, the best inn, and lay in the room the king lately lay in'.

These coaching inns thrived; but then, in 1845, the railway came to Guildford from London via Woking Common and change was afoot. Its arrival, along with other lines in the years that followed, saw the town grow on an unprecedented scale. In fact, most of Guildford's history, if looked at in terms of volume, has happened since the mid-nineteenth century.

Eighty Pubs and Half a Dozen Breweries

More people therefore demanded more beer and it has been estimated that around eighty public houses were established in Guildford during the nineteenth century. At this time there were half a dozen breweries in the town, all of which had a number of tied public houses. Moreover, it was a convenient place to brew. There was a plentiful water supply, and the main ingredients for beer, namely barley and hops, were grown locally.

On into the twentieth century and, as Guildford continued to expand, so further pubs opened. Of course, that expansion swallowed up places that had once been separate villages in their own right with their own pubs.

In recent times there has been a good deal of change to our local pubs and their ownership. Guildford's breweries which our forebears would have known have long gone, along with many pubs too. However a good deal of pubs that remain in the town area and in nearby villages appear to be successful. Many have adapted to the needs of today's customers, offering a good choice of meals as well as a range of beers, wines and spirits that are far better than were on offer in the 1970s and '80s.

Interestingly, there has been a revival of brewing here too. A number of microbreweries have become established; the Hogs Back Brewery, the Surrey Hills Brewery and the Little Beer Corporation are three that are close by. Their real ales and craft beers can be enjoyed in an increasing number of Guildford pubs. This book features pubs currently in business in the town centre, the immediate suburbs and a selection from neighbouring villages throughout the borough of Guildford.

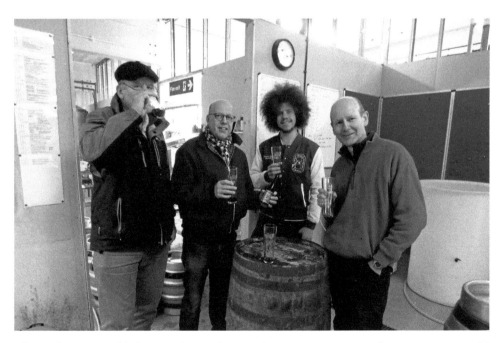

The author (second left) gets the Little Beer Corporation to try a forty-seven-year-old bottle of Friary Audit Ale.

Pubs in and Around the Town Centre

THE KEYSTONE, Portsmouth Road

We begin our tour of Guildford pubs in the area of the town centre where brewing was once concentrated. Here in the parish of St Nicolas, a stone's throw from the church itself, there were at one time during the nineteenth century three breweries.

Wine merchant Thomas Taunton senior established his Castle Brewery in 1834 on land between Portsmouth Road and Bury Street. Following his death in 1839, his son, also called Thomas, took over, but in 1842 he sold part of the brewery to a John Henry

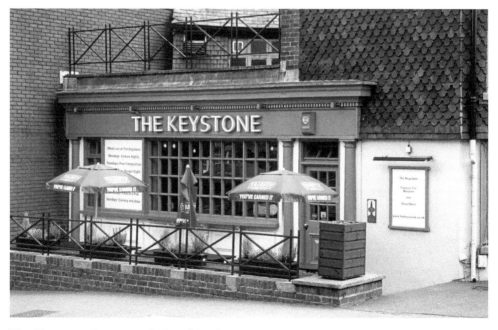

The Keystone, Portsmouth Road, is also an arts venue.

Palm trees in the garden at the rear of the Keystone.

Lascelles. Two years later Thomas Taunton established a new venture that he named the Cannon Brewery and built a pub next to it, which he also called the Cannon (today the Keystone). There was another death in 1849, this time of Mr Lascelles, but his wife and three sons continued running the Castle Brewery, which later became Lascelles, Tickner & Co. By the turn of the twentieth century, it was Guildford's second largest brewery.

Meanwhile, Thomas Taunton, along with and his brother Silas, continued with the Cannon Brewery and in 1865 established the Friary Brewery in another part of the town. However, they dissolved their partnership in 1873, and Thomas then joined forces with a Charles Hoskins Master. Alas, this only lasted a mere six months and the latter bought Thomas out and the Taunton family disappeared from brewing in Guildford. Mr Hoskins Master sold the Cannon Brewery to Thomas Lascelles and George Tickner, but retained the Cannon pub as part of his growing Friary Brewery empire – more of which later. The third brewery in the St Nicolas parish was Crooke's, situated beside the river – and more of that later too.

The Cannon Becomes the Powerhouse
The Cannon was once a well-known Friary Meux pub. However, after the government broke up the monopoly of the UK's six national brewing companies and the thousands

of pubs they owned in the early 1990s, under new ownership the Cannon was renamed the Powerhouse for a short time. The name was probably influenced by the Central Electricity Generating Board offices next door, built in the early 1960s on the site of the former breweries and later occupied by the Guildford Glass Works. That office block has long gone and the site still awaits redevelopment.

Today's Keystone is a far cry from the Cannon that was originally a humble taproom, and the pub now has a good reputation as an arts venue. Under the name of Firefly @ The Keystone, the pub hosts live music (dance, electronic, folk, country, rock, reggae, ska and pop), poetry nights, talks on all things scientific and DJ sets. All this is spearheaded by an enthusiastic group of people that includes the pub's owner, Richard Jaehme, and Nick Wyschna, the man behind the excellent Guildford Fringe Theatre Company. Artwork is also on display by Guildford-based artists.

A wide range of food is served seven days a week up until 11 p.m. They also offer plenty of beers (including craft beers) from around the world. Not only is the food offered as takeaway, but they deliver too – including beer, tobacco, snacks and condoms!

THE WHITE HOUSE, High Street

It would be easy to assume that the White House, standing next to the Town Bridge, has been offering refreshments and hospitality to locals and visitors to Guildford for many years. It has a stylish entrance complete with columns that resemble, in a

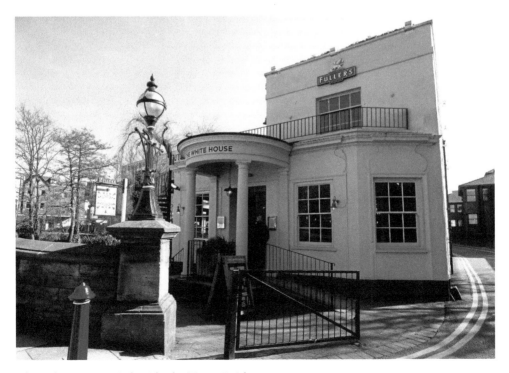

The White House is beside the Town Bridge.

The White House opened in 1994.

small way, that other White House in Washington DC, the home and workplace of the president of the USA. However, outward appearances can be deceiving as this has only been a pub since 1994. Nevertheless, the site it occupies has a good deal of history and was at one time a small island near the west bank of the River Wey.

Working backwards, the White House building which stands today dates to around the 1950s, and by the early 1960s was occupied by solicitors Wells & Philpot and industrial bankers Bowmaker Ltd. On the site before these was Cuthbert's motor garage. Prior to that the land was occupied by stone and monument masons Arthur Moon & Sons, who also owned a timber yard opposite, where today's Debenhams store stands. At one time there had even been a short-lived plan to build a theatre on the White House site – long before the town's present Yvonne Arnaud Theatre, just upstream on the opposite bank, was ever dreamt of.

Bennett's Island

The channel between the aforementioned island and St Nicolas church was filled in in 1831 and is now the road to Millmead. Back in the eighteenth century it was known as Bennett's Island and in the thirteenth century was called 'Wewstnye', meaning Western Island.

Today's White House pub has the attraction of being on the riverside and a recent revamp has further enhanced this with plenty of outdoor seating on the terrace and great views of the river inside the conservatory. It is one of London brewer Fuller's 400 pubs, hotels and inns across the south of England; therefore, expect its popular range of beers including the classic London Pride, ESB, HSB, as well as many more.

Food is served all day and on its website its says, 'The White House is home to delicious sharing platters, ideal for a catch-up with friends, plus light bites and fresh sandwiches, perfect for a quick lunch away from the office.' The terrace and an upstairs room can be hired for private functions.

GEORGE ABBOT, High Street

It is most appropriate that Guildford has a pub named after its most famous person within our nation's history. It is reputed that Archbishop George Abbot was born in 1562 in a humble dwelling that once stood close – where the car park is now situated in front of the pub – to the pub that now bears his name. Interestingly, it later became the Three Mariners alehouse, but was demolished in 1863 – what a shame it does not survive!

Abbot was the son of a cloth worker. A legend goes that when his mother was pregnant with him she dreamt that if she ate a pike her child would become famous. She then drew a bucket of water from the river and, lo and behold, it contained a small pike, which she then cooked and ate. It was suggested the boy came from a poor family and the pike story and prophesy led to some wealthy gentlemen paying for his future education. However, historians are now of the opinion that the family must have had some wealth as not only did the boy receive his early education at the town's Royal Grammar School, but of his five brothers one became Bishop of Salisbury and another Lord Mayor of London.

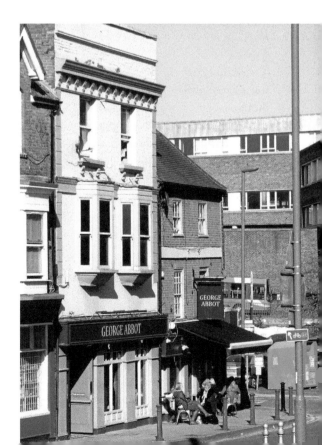

The George Abbot was previously called the Greyhound.

Quiz nights with Alan are popular on Thursday nights.

Turmoil in the Church of England for the Archbishop

George Abbot went to Balliol College, Oxford, aged sixteen. He later took holy orders and rose to become Archbishop of Canterbury in 1611, a position he held until his death in 1633. His time as archbishop was one of turmoil in the Church of England and he may not have been that popular and was probably rather narrow-minded. But he never forgot his home town, and his gift to Guildford is the Hospital of the Blessed Trinity (better known as Abbot's Hospital), an almshouse in the High Street, which it is to this day. He is buried opposite in Holy Trinity Church.

The pub has only been named after him since the 1990s. It was previously named the Greyhound and the building dates to 1808, and it closed after a fire in 1990. The pub has an unlucky history as it was also badly damaged by floodwater during Christmas 2013, closing for two and a half months to undergo a major refit.

It appears to have originally been built following the demolition of a previous pub with the same name, one which may have stood at what is now the junction of High Street and Portsmouth Road.

Suffolk-based Greene King plc owns the George Abbot and you can taste its renowned IPA beers, available on hand pump, as well as its keg beers, lagers and guest beers. Greene King has its own Abbot Ale, a tasty brew at 5% ABV – the perfect drink to toast the legacy of Archbishop George Abbot.

THIRTY3 HERTZ, Park Street

Describing itself as 'Surrey's house music boutique' with 'the most exciting DJs out there in the most intimate environment you will ever have the chance to see them in', Thirty3 Hertz certainly does not fall into the category of traditional drinking establishments. Technically, it is a bar / nightclub, with the emphasis on cocktails, and is open on Tuesdays, Thursdays and Saturdays from 10 p.m. until 2 p.m. Entry is £3 before 11.30 p.m., £5 after.

It has had a number of owners in more recent times, having traded under the names of Platform 9 (it is close to Guildford railway station, which has eight platforms), Scrumptious and Divas. However, for most of its history selling intoxicating liquors it was known as the Plough.

In 1810, a Guildford banker, William Sparks, built a number of cottages in Park Street, which were named Sparks' Row. In 1845 a brewer, Thomas White, bought three of the cottages and it is believed this is when the Plough as a pub came into being. It passed down through a couple of generations of the White family and was sold in 1890 to Guildford's Friary, Holroyd & Healy's Brewery.

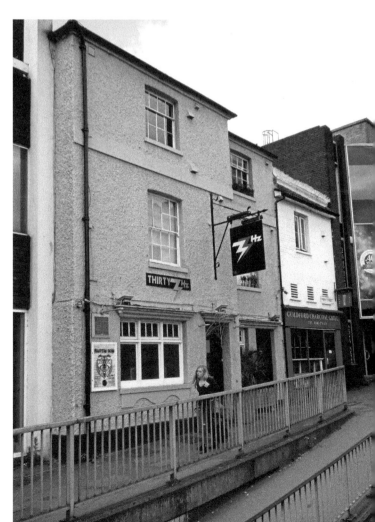

Thirty3 Hertz in Park Street plays host to DJs.

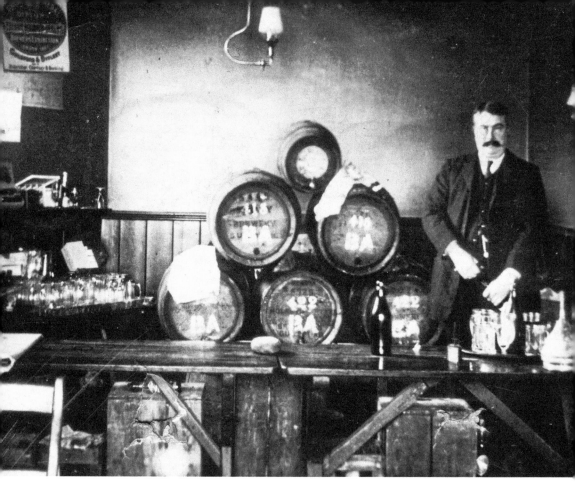

Edwin Moss was a landlord when it was the Plough.

Enterprising Landlord, Edwin Moss

A rare photograph of an interior of a Guildford pub taken more than 100 years ago shows licensee Edwin Moss who took over the running of the Plough sometime in the 1890s. This fascinating picture would appear to reveal that it was somewhat of a dive, or was this typical of the times? The 'bar' appears to be a couple of trestle tables propped up by wooden crates. On the wall, top left, is a Friary brewery calendar. Alongside the wooden casks and on the bar can be seen a metal funnel and a sponge, while Mr Moss (born 1886) is holding a corkscrew.

Edwin Moss not only ran the Plough but had a confectionary shop almost next door, and by 1917 he owned a shop in Friary Street selling fruit and confectionary. He died in 1935.

THE RODBORO BUILDINGS, Bridge Street

Pub chain JD Wetherspoon's Guildford establishment occupies a landmark building with a wealth of history. The Rodboro Buildings is, like so many 'Spoons' pubs, a popular place with customers of all ages. It's value-for-money pub food is popular during the daytime with families and older folk, while, come night-time, younger

Guildford's Wetherspoon's pub is in
the Rodboro Buildings.

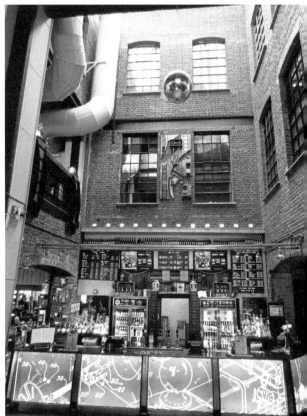

The building was once a motor works,
then a boot factory.

pub-goers flock here as it is conveniently sited on 'the strip' of the town's bars and nightclubs.

The building may have been the first purpose-built car factory in the world. Back in 1901, the fledgling motor vehicle maker Dennis Bros was expanding rapidly in Guildford – it had outgrown premises in the former militia barracks in Friary Street. Owners, brothers Raymond and John Dennis, saw the building in Bridge Street going up and soon moved in – even before it was finished.

It housed Dennis Bros assembly shop, blacksmiths, paint and polishing rooms. These were on the first and second floors, and a lift took the completed vehicles to the showrooms on the ground floor. The first of Dennis' famous fire engines was made there in 1908, but in 1913 the firm ceased making cars and concentrated on commercial and specialist vehicles. During the First World War, it made 7,000 3-ton lorries for the War Department.

Boots and Shoes Once Made Here

The firm continued to grow and eventually moved all production to its factory at Woodbridge on the outskirts of Guildford. From 1919 to 1928 the building was home to the Rodboro Boot & Shoe Co., from which the building gets its name. It then had a variety of occupants that included firms engaged in engineering, printing and photographic finishing. During the Second World War the British Red Cross used part of the building as a packing centre for parcels destined for prisoners of war. Later occupants included knitwear makers Keefe & Lewis, a pet shop, confectioners and automobile agents Godfrey Stanley and Clare's Motor Works. It was also where the Observer Corps Club was founded by Mr R. O. Dowdeswell, whose own stationery and print firm was based there.

However, by the 1980s the building had become empty and forlorn. There were plans to demolish it for road improvements through the busy town centre, but after protests proclaiming it an historic building, it was saved. It is a rather good building for a large pub: 'Spoons' is on the ground and first floor, with the Academy of Contemporary Music utilising the rest of the building. Wetherspoon's pubs are well known for their 'cheaper' drinks and a range that changes regularly. Recently it has introduced three bottled beers from Tongham's Hogs Back Brewery into its range of craft beers and ciders.

THE WEYSIDE, Millbrook

The Weyside has the credentials for being the best riverside pub in the area. It looks out over Millmead and is certainly a great place to sit outside on its terrace when the weather is fine.

To many who know a thing or two about local pubs, this will always be known by its former name – the Jolly Farmer. Some may even recall that for a short while a few years ago it was called the Boatman.

The building we see today is not the first pub on that site; in fact, there were several buildings here, one of which, at a date that seems to be lost in the mists of time, became a pub. The will of a William Drewett, who died in 1874, states that he left a number of dwellings – a blacksmith's shop, a wheelwright's shop, outbuildings and a yard – to his

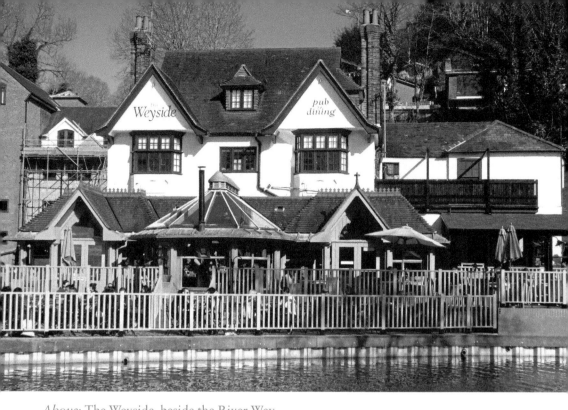

Above: The Weyside, beside the River Wey.

Below: The original pub when it was called the Jolly Farmer.

daughter Sarah Arnison. Perhaps it was during her ownership of the land that one of the buildings became a pub.

This part of the river has long been enjoyed by Guildfordians either out for a stroll along the river, or boating on it. Chas Leroy and his family, who were from Belgium, hired out rowing boats and had a tearoom just downstream from here. By 1893 the Leroys were running the Jolly Farmer. Their boathouse was also the headquarters of the Guildford Swimming Club and the local branch of the Life-Saving Society. Next door to Leroys, in the early 1900s, the Allen family owned a fine wooden boathouse with a first-floor tearoom. The building survives and has recently been restored.

Jolly Farmer is Rebuilt

In 1902, the husband of the previously mentioned Sarah Arnison leased 'a public house, stable and yard outbuildings … called or known by the name or sign of the Jolly Farmer' to Guildford's Friary, Holroyd & Healy's Brewery, for twenty-one years at £75 per annum. However, in 1911, the brewery bought the building for £1,750 and then set about rebuilding the pub.

The Millbrook side of the building still retains the date '1913', but the wording on two other panels that once read 'Jolly' and 'Farmer' have been removed.

Members of Guildford Rowing Club, who patronised the pub in the 1950s after time spent on the water, enjoyed a popular cocktail of the period comprising whisky and ginger wine, known as a whisky mac. During the 1960s and '70s the pub was owned by the Peart family, who were also caterers to Guildford Civic Hall.

Today the Weyside is owned by London brewer Young & Co. The pub serves its Bitter and Special ales with guest beers too. It has a good selection of food, and quiz nights are on Wednesdays.

THE BRITANNIA, Millmead

Small yet perfectly formed best describes the Britannia. It looks out over the river towards the Yvonne Arnaud Theatre and was a regular haunt of students from the Guildford School of Acting, which was once nearby until it relocated to the University of Surrey campus.

Light and airy inside, it is a lot different from the two-bar pub that the author remembers from his younger days. It was the first pub he bought a drink in; it was the summer of 1974 and he was just fourteen years old. He and a couple of mates (they were just a little older) were surprised to be served with bottles of light ale.

Once he had reached the legal age to drink alcohol, it was a favourite haunt for him and his peers. Friday nights usually started at 'the Brit', with games of table football in the public bar with its wooden floorboards.

If a seat in that bar couldn't be found, they sometimes retired to the tiny saloon bar.

Back then it was owned by Brian 'Bubsy' Welch, a well-known character. The author recalls that he didn't seem to spend much time serving behind the bar, but turned up at closing time to order everyone out. He and his wife Jane also ran the Queen Victoria at Shalford.

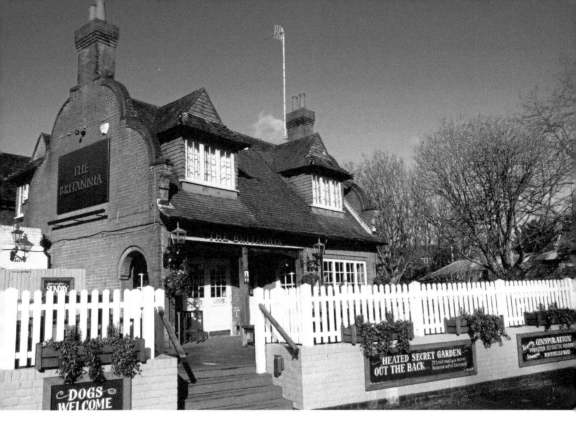

Above: The Britannia is beside the River Wey at Millmead.

Below: A friendly welcome awaits at the Britannia.

The Brit Burns Down

The origins of the pub date back to 1838 when a John Mason leased a building on the site which became the Britannia beerhouse. This was the original pub and was largely constructed of timber. In 1890 the lease passed to the Friary, Holroyd & Healy's Brewery. Unfortunately it was destroyed by fire in 1912 and when the brewery wished to rebuild it in the same style, Guildford Corporation insisted it be made of brick. The brewery agreed on condition that it could purchase the freehold. This was agreed by the Charity Commissioners and the sum paid was £1,000.

Somewhat uncharacteristically renamed Scruffy Murphy's for a few years, it is thankfully the Britannia once again and is owned by Kent brewers Shepherd Neame. It boasts a relaxed and friendly atmosphere serving good pub food, a choice of cask ales, distinctive international lagers and a wide selection of wines. It hosts live music on Thursday nights.

THE KING'S HEAD, Quarry Street

Strange goings on have been reported in the King's Head, which gives it the reputation of being the most haunted pub in Guildford. The leader of the popular Guildford Ghost Tour, Philip Hutchinson, is an expert on local paranormal activity and knows many of the ghost stories associated with the pub.

In the 1980s the then head barman saw the apparition of an old lady 'staring back at him, grey and indistinct'. From the cellar a female voice has called out the names of

The King's Head is in Quarry Street.

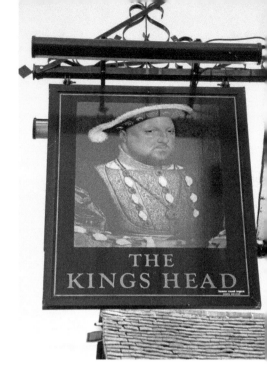

The King's Head has a reputation for ghosts.

staff, but when they investigate there's no one there. A man has been seen reading a newspaper who then vanishes. And a little girl in Victorian dress has been seen several times standing in the doorway before moving across the bar and disappearing through the French windows.

And so the mysteries continue. Philip tells of the time he approached the landlord to arrange an overnight investigation of the pub. The landlord was fixing the PA system and as Philip asked him about his intended investigation one of the speakers blew. Philip said there is a legend connected with the pub: if there is any unpleasantness inside, the plumbing and electrics are interfered with.

Added to this is the alleged story of one night in the 1970s when the police raided the pub on suspicion of drug taking and dealing. Some say they heard the sound of a police radio coming through the speakers of the jukebox. The police voices mentioned a raid was about to take place. Evidently, the pub emptied rather quickly!

Foundations Likely to Have Been a Part of the Castle Wall

The building itself is thought to date back to the seventeenth century and was most likely two houses at one time. However, much older foundations in the cellar appear to have been part of a square corner tower of Guildford Castle's curtain wall. After the ceiling of the pub collapsed in 1995, archaeologists took a detailed look at the cellar and discovered that during the medieval period it had been a cobbler's shop.

The earliest reference to it being a pub dates to 1819, when Guildford brewer Francis Skurray sold it to another town brewery owned by Edmund and William Elkins.

Hodgsons Kingston Brewery acquired the pub in 1847 and then in 1943 it was bought by Courage & Co. Today the King's Head makes the most of its history and ghost stories, and why not! During weeknights different specials take prominence on

the food menu: Monday, curry (and quiz night); Tuesday, pizza; Wednesday, burgers; Friday, fish and chips; and a traditional roast is served on Sunday. The raised terraced area at the back is always popular – look out for the suit of armour; it's not a ghost!

THE STAR INN, Quarry Street

Standing just along Quarry Street and near the High Street, the Star Inn has an interesting interior split over three levels. It affords some cosy and snug places in which to enjoy a drink and perhaps a bite to eat. Furthermore, it has a function area known as The Back Room, which plays host to live music, comedy, theatre and film nights.

The Star Inn is certainly one of the town centre's oldest pubs with the earliest recorded mention of an inn by the name of the Star being 1723, when mortgaged to a John Child from a baker by the name of Arthur Davis. He repossessed the property, after which it then had a succession of owners including victualler Edward Sturt, carpenter Arthur Alexander and cheesemonger John Stovell, and later his son George. All of these may have had tenants running the Star, as when Stovell senior owned the inn the occupant was a Henry Moon.

More owners came and went including, in 1833, Thomas Chennell, the owner of the town's Stoke Brewery. The occupant at that time was a Jessie Boxall (d. around 1846), who had been there since around 1792, a name that was to be associated with the pub for a long period in the years that followed. However, a William Smith had taken over

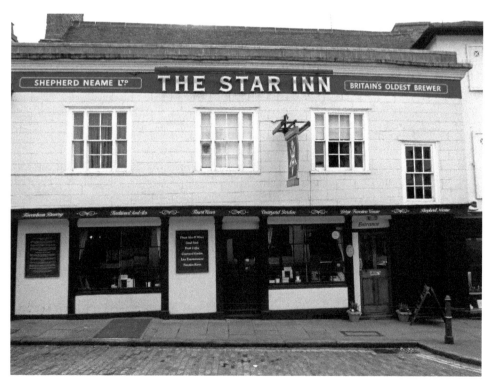

The Star Inn, Quarry Street.

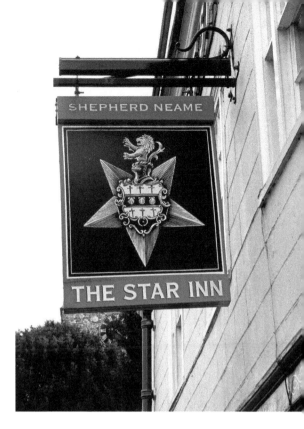

The Star is one of the town centre's oldest pubs.

the running of the Star by 1839, yet in 1845 the freehold was purchased by another Jessie Boxall (1822–94), grandson of the previously mentioned publican.

This Jessie Boxall was a dealer in porter and spirits and, according to stoneware bottles that exist with his name on, he also brewed at 'The Star Brewery'. Confusingly, but often the case when delving into family histories, this Jessie's father (d. 1852) had the same first name and was a cooper by trade. Let's call the later one Jessie Boxall III. He was a member of the town council and was well known for sitting outside his pub smoking a long clay tobacco pipe, always with a hat on but no coat.

The function room was built in the 1840s and was originally called the Court Room. Never a court of law as such, it was the meeting room of the Guildford Castle Court of the Ancient Order of Forresters. It lays claim to being the place where the Stranglers, who emerged during the 1970s punk rock era, played their first gig in 1974 when called the Guildford Stranglers, after the town where they were formed.

The Star Inn is a Shepherd Name pub, which proudly claims to be Britain's oldest brewer, founded in Faversham, Kent in 1698. Its famous beers include Master Brew, Spitfire, and its Whitstable range of ales – Bay, Organic and Black Bay.

THE THREE PIGEONS, High Street

From its outward appearance you may be fooled into thinking that the frontage of today's building dates back several hundred years. In fact, it was the result of a rebuild in 1918 after a disastrous fire two years earlier. The elevation you see today is said to be a copy of an old house in Oxford's High Street.

Left: The Three Pigeons is at the top of High Street.

Below: There are bars on two floors of the Three Pigeons.

The pub has a long history, with its first mention in a property conveyance of 1764. In 1876 it was in the ownership of a Thomas White, who owned the Bridge Brewery in Godalming along with a number of tied houses in the area. He sold up to Guildford's Friary, Holroyd & Healy's Brewery in 1890, which included the Three Pigeons.

The fire, on Saturday 17 June 1916, that engulfed the pub started in an adjoining property, Messrs Gates' grocery and dairy company. Landlord Mr Dalby awoke to discover the fire in a building used as a warehouse and to the rear of Gates' shop. The fire quickly spread and destroyed the pub's bedrooms on the top floor and the dividing wall with Gates' store. Abbot's Hospital, situated on the other side of Gates' premises, was in danger of catching alight too, but valiant work by the Guildford fire brigade prevented the fire from causing too much damage to the historic building. All who were in the pub escaped unharmed and landlord Mr Dalby even opened for business the next day despite water damage to his ground-floor bar.

Further Change in the High Street After the Pub is Rebuilt

The pub was rebuilt and that part of the High Street was soon to have a completely new look. Back in 1913, buildings that extended from the pub towards what is now the Upper High Street had already been demolished to make way for a scheme to widen the road due to increasing traffic congestion. Part of this had been Ram Corner, where the Ram Inn had stood. In the early 1920s, the bank chambers were built in a neo-Georgian style on part of the site that curves round into North Street.

The pub has long had the nickname the 'Three Pigs' and has a characteristic 'spiral staircase' linking the ground- and first-floor bars. It had an extensive refit in the 1970s, and its rather fine plaster ceiling dating back to the nineteenth century has luckily been retained. For a brief spell it was named the Farriers.

It offers a wide range of beers and ciders from around the world, and also serves wines and cocktails. Check out its range of good pub food and meal deals.

THE ROYAL OAK, Trinity Churchyard

Although somewhat tucked away in a quiet location but close to the town centre, there are three ways to get to this pub: it can be entered down steps from Sydenham Road, or by walking along either the path that runs through Holy Trinity Churchyard, or the path to the side of it.

The Royal Oak is a listed building and dates back to at least the seventeenth century. It has been suggested that it may once have been the rectory to the church, and records would indicate that its history as a pub only begins in the early 1870s. It being No. 2 Trinity Churchyard, it was put up for sale at auction along with its adjoining property in 1867 by Olivia Fathers and Dr Thomas Jenner, a surgeon who developed the Charlotteville area of Guildford. The property was offered as a dwelling house and business premises, and the buyer was a George Trimmer, a brewer from Farnham – he bought it for £350.

Over the years he expanded his brewing empire with his Farnham United Breweries. It owned a number of tied houses in both the Farnham and Guildford areas. Courage & Co. bought the business in 1951. Like many pubs, the Royal Oak has had a series of

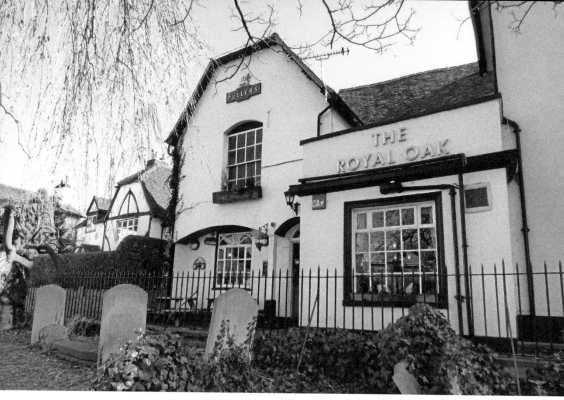

Above: The Royal Oak can be found behind Trinity Churchyard.

Below: Locals say the Royal Oak is a 'real pub'.

revamps and redecorations over the years, but has managed to retain a cosy and friendly atmosphere. Today it is a Fuller's pub selling a range of real ales and bottled beers. It runs a couple of beer festivals a year, and although small in size, hosts live music on a regular basis. There is some outside seating at the front (churchyard side) and rear.

Colourful and Noisy Twelfth Night Revelry

Every year on Twelfth Night, which falls on 6 January, the Pilgrim Morris Men of Guildford tour a number of the town centre's pubs performing their traditional mummers' play for the occasion. The Royal Oak is visited during this colourful and noisy event as they act out the play, sing traditional carols and pass round the wassail bowl under the direction of the 'King of Misrule', who is specially chosen at the start of the evening.

If you are in the Royal Oak, look out for some cross marks usually chalked high up on one of the wooden beams. These are made by the morris men on Twelfth Night and are known as apotropaic marks. They are made so as to bring good luck to the pub and to prevent evil spirits entering.

THE KEEP, Castle Street

This pub takes its name from that rather austere building within view – namely the Great Tower of Guildford Castle, more often called a keep. It prides itself on keeping

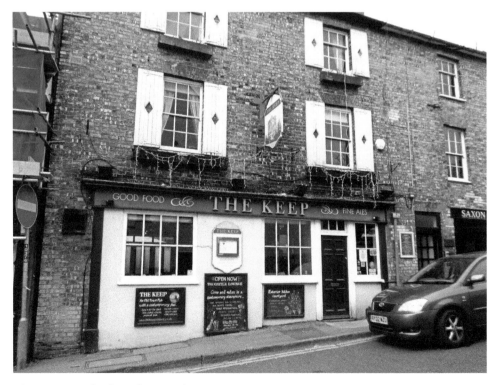

The Keep can be found in Castle Street.

Local history nights are popular at the Keep.

the tradition of the English pub alive 'with every pint that's poured', while hoping that as soon as customers walk through the door 'they'll think they've been transported back to a better, simpler time'.

The Keep probably started out as a simple beerhouse in the early part of the nineteenth century, but was going by the name of the Two Brewers by the mid-1850s. Thomas and Silas Taunton of the Cannon Brewery obtained a twenty-year lease on the property in 1871, and then in 1886 Farnham brewer George Trimmer bought the pub outright. Becoming a Courage house in 1927, it remained as the Two Brewers until it had several changes of name in quick succession from the mid-1990s – almost certainly the most of any Guildford pub! It became the Old Guildfordian, then the Mash Tun, followed by the Three Tuns and then Mustard, before becoming the Keep in 2007.

Spanish Lady with Her Distinctive Traditional Headdress

For forty-three years, from 1891 to 1933, the pub was run by one family. Alfred Dean had been a regular soldier with the Army Service Corps. He met Clara, who became his wife, when he was stationed in Gibraltar. She had been born near Valencia in Spain, and when he left the army they moved from Aldershot to Guildford. Alfred died in 1899, but Clara continued to run the pub. She was a well-known character about

Guildford and could often be seen in the High Street doing her shopping and wearing her mantilla – the very distinctive traditional Spanish headdress. She died in 1941.

Of their six children, Elliot James also became a soldier. At the start of the First World War he was stationed in Egypt. He made one trip home to see his family at the Two Brewers and was on leave for just forty-eight hours. He rejoined his regiment and fifteen days later, on 20 November 1914, died of wounds received in battle.

Today the pub is run by Brian Matthews and Jane Lyons, who support local events, hosting them at the pub. These have included record fairs run by Ben Darnton of Guildford's Collector's Record shop in nearby Tunsgate, and more recently talks on local history in conjunction with the popular Facebook group page he founded called Guildford Past & Present. Indeed, the author is a speaker at these.

ROBIN HOOD, Sydenham Road

The land on which the pub stands was transferred in 1863 by Dr Thomas Jenner Sells, the developer of Charlotteville (and who named all the streets after famous doctors), to a William Pimm and a John Engall. They built the pub and presumably employed a landlord, the first recorded occupant being a James Balchin.

In 1883, the pub was being leased to Guildford's Friary, Holroyd & Healy's Brewery, who bought it outright in 1896 for £1,200. This was at a time when the brewery was most aggressive in its business dealings, buying up other local breweries and their tied houses and expanding in all directions from its base in the town where today's Friary Centre is.

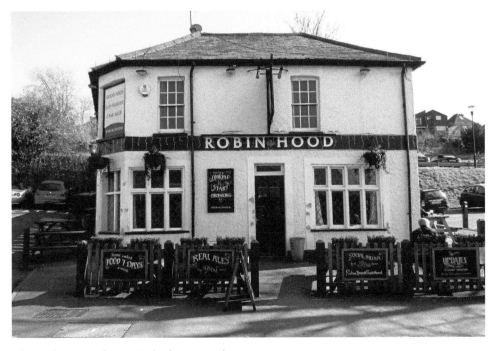

The Robin Hood is in Sydenham Road.

Everyone is welcome at the Robin Hood.

Smell of Beer Being Brewed Wafted Over the Town

As previously mentioned, Charles Hoskins Master acquired the Friary Brewery from Thomas Taunton in 1873. It became Guildford's largest brewery. Its buildings were a familiar landmark and the smell of the beer being brewed wafted over the town. By 1956 it owned 440 licensed houses and in that year merged with Meux of London to become Friary Meux. The giant Allied Breweries took it over in 1963 and in 1969 brewing ceased in Guildford and production was transferred to Romford in Essex.

The Robin Hood may be a small pub, yet it manages to squeeze in bands playing live music. As it's an independent pub, beers are offered from a wide range of breweries on a rotation basis. These include those from local brewers such as the Hogs Back, Dorking, Tillingbourne, Little Beer Corporation, and Surrey Hills breweries. It was voted Pub of the Year 2015 by the Real Ale Touring Society. On the food front, it's getting a good reputation for its burgers and steaks.

THE ALBANY Pub & Dining Rooms, Sydenham Road

The Albany Pub & Dining Rooms is an independent gastropub – and proud of the fact! It opened in 2006 after a good deal of refurbishment of what was the Rats Castle.

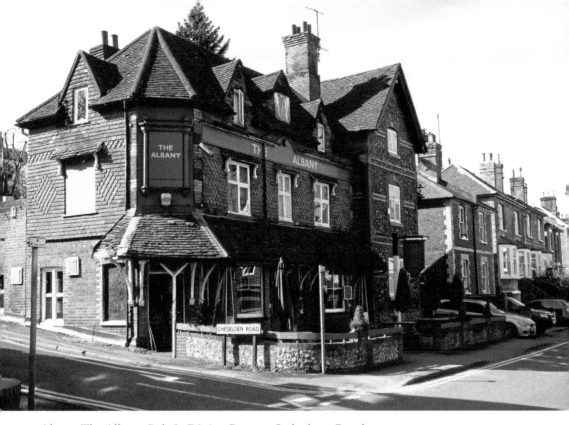

Above: The Albany Pub & Dining Rooms, Sydenham Road.

Below: The pub's dog Treacle has a beer named after her.

The site was another plot of land sold by Charlotteville developer Dr Sells, this time in 1865 to builders John and James Smith. They built the pub, but why it took the curious name the Rats Castle is not known, but it seems Dr Sells made sure residents of his estate (named after his wife Charlotte) had places to drink in. He also sold land in Cooper Road on which the Foresters beerhouse was built. Later becoming the Foresters Inn, it was renamed the Pig & Tater in 1976, but became the Foresters once again until it closed in 2012.

The Rats Castle was leased to the Tauntons of the Cannon Brewery and then to Charles Hoskins, Master of the Friary, Holroyd & Healy's Brewery. Not surprisingly, that brewery eventually snapped it up, purchasing it in 1905 from the building's then owner, Emily Dell.

A Light and Bitter with Double Diamond

Guildford resident Pete Brayne has some good memories of the Rats Castle. He says, 'I started to frequent the pub in 1970, aged sixteen. A light and bitter was my drink – which usually meant you got about two-thirds of a pint of bitter and a bottle of light ale. This was before the Campaign for Real Ale, so the bitter was usually Double Diamond which, contrary to the jingle, didn't "work wonders"! Although it was a fairly rough and ready pub, I only recall one fight. The football table was one of the main attractions, but there was also bar billiards and, of course, darts. I celebrated my eighteenth birthday there and the landlord didn't seem too worried that I had been a regular for almost two years by then. I also had my first car back then: a 1954 Morris Minor with split windscreen and flipper turning indicators. It had been hand-painted purple. So I then started to drink further afield with scant regard, I might add, to drink-driving in those days!'

The Albany is a far cry from the Rats Castle of nearly fifty years ago. It has a Cask Marque accreditation for its real ales with three different brews on offer and seasonal ales too. Part of the Albany is a restaurant area and the home-cooked menu includes a range of starters, platters, mains, pub classics (steaks, burgers, fish and chips) and desserts. It offers a buffet menu for ten or more people, and there is seating outside at the front and a delightful secluded garden to the rear.

ROGUES BAR, Epsom Road

The venue for those aged over twenty-five has been at this location for ten years, and was previously in the Prudential Buildings at the town centre end of Epsom Road.

Originally called the Sanford Arms, the site was leased in 1860 to that speculative builder of public houses, James Smith. He would have realised that this part of the town, on either side of the Epsom and London Roads, was being developed for housing and saw the plot as an ideal location to build a pub.

Smith soon passed on the ninety-nine-year lease at £10 per annum to Hodgsons Kingston Brewery. The Sanford name appears to have been chosen as this was a family to whom the Hodgsons were related. One of the pub's early landlords was a J. R. Ames, who had been the master at the Guildford Union Workhouse which was then nearby.

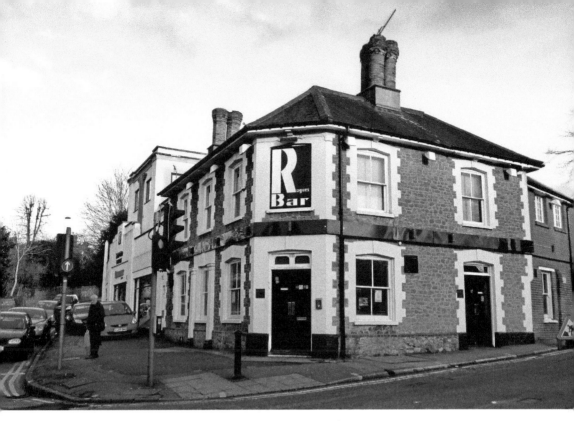

Above: Rogues Bar can be found on the Epsom Road.

Below: Rogues was previously called the Sanford Arms.

In 1867, Hodgsons bought the freehold of the pub along with adjacent outbuilding and stables. In 1924 these were converted into a motor garage. A garage in the art deco style replaced it and it still stands today, as a cycle shop with apartments above.

Watering Hole for Hospital Staff after Finishing Their Shift

St Luke's Hospital was once close by and therefore the Sanford Arms was a regular place for some members of staff after they had finished their shifts and also students from the School of Radiography, also based there.

Rogues today hosts live music, open-mic nights, quiz nights and other special-themed events. It can also cater for private functions of between thirty and sixty people. The owners claim to have the 'biggest and best beer garden in Guildford' – it certainly reaches a long way up a slope parallel to Warren Road. Part of the garden has covered seating with outdoor heaters, while the far end is terraced and something of a suntrap with plentiful seating.

FIVE & LIME, Leapale Road

Not a traditional pub by any means, the pulse of Five & Lime is soulful house, hip hop and dance music played by DJs late into the night, along with its clean-looking decor and walls stripped back to their bare bricks. It has been described, quite correctly, as a modern bar and party venue, and young people seem to love it. It is a far cry from

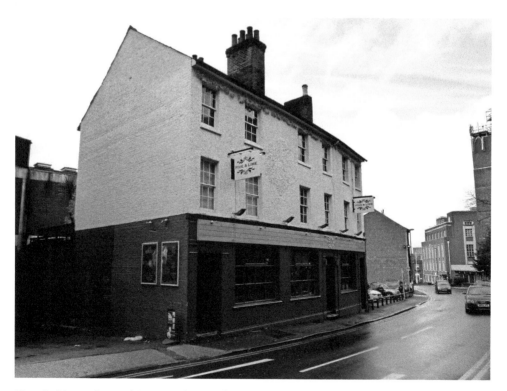

Five & Lime, situated in Leapale Road.

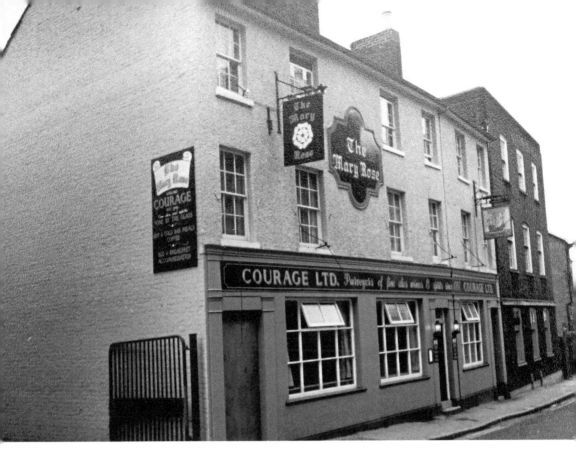

The pub when it was the Mary Rose.

over thirty-five years ago when it still went by its original name of the Carpenters Arms. In fact, the decor was fairly basic back then, and it is fair to say it was a bit of a dive! It was badly damaged by fire in 1976, but was quickly patched up and reopened. However, in 1982 it was renamed the Mary Rose, after the then recent raising of the remains of Henry VIII's warship of the same name from the Solent, which had been headline news.

The pub was originally built with two other buildings as houses in the 1860s, but not long after became a licensed house. There was a change of ownership in 1876, when Farnham brewer George Trimmer acquired it. Four years later he bought the two other properties that were absorbed into the pub.

From Carpenters Arms to Mary Rose and then Sailing into Oblivion

As the Mary Rose, with a stained-glass window in a door depicting a galleon, it survived into the 1990s until it sunk without too much attention. It is fair to say that its position, just off North Street and with not a lot else around it, perhaps did not help in swelling the clientele.

It's interesting how ringing the changes with a new theme and approach can turn a pub around. Maybe choosing a name far removed from a traditional one has helped as well.

THE GUILDFORD TUP, Chertsey Street

The hanging sign outside the Guildford Tup gives a clue as to the meaning of the name. The sign's artwork incorporates a stylised ram's head with horns. *Collins English Dictionary* defines the noun 'tup' as an un-castrated male sheep (a ram), and the verb 'tupping' to cause a ram to mate with a ewe – so now you know!

The pub features live rugby and football matches on Sky, BT Sports and ESPN channels. They also fit in live music on Saturday nights. Singer and guitarist Gavin Thomas is a regular performer and he's well known locally, playing acoustic cover versions of songs by the likes of Bob Dylan, Rolling Stones, Neil Young, Stereophonics, Coldplay, Kooks and many more besides.

To older Guildford pub-goers it will always be remembered as the Spread Eagle. In the mid-1850s a carpenter by the name of Eli Beagley owned land in Chertsey Street and at around that time he built a beerhouse here that he named the Carpenters Arms. In 1873, it was bought, along with some adjoining cottages (demolished in 1967), by Farnham United Breweries for £1,400. As there was already another Carpenters Arms in the town, the name was changed to the Spread Eagle.

At one time pubs were often used as pick-up points for local horse-drawn carriers and the Spread Eagle was the collection and drop-off point for goods as well as passengers to and from Godalming, Milford, Hindhead and Grayshott. The carriers departed at 2 p.m. on Tuesdays, Thursdays and Fridays. It was also among the local

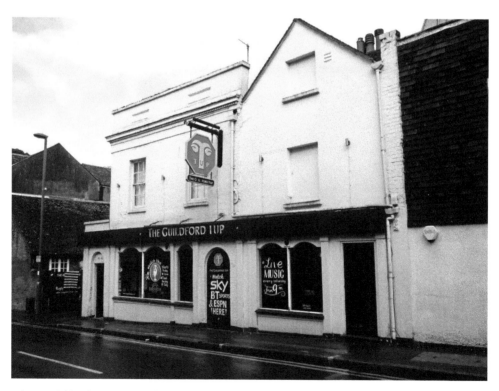

The Guildford Tup is in Chertsey Street.

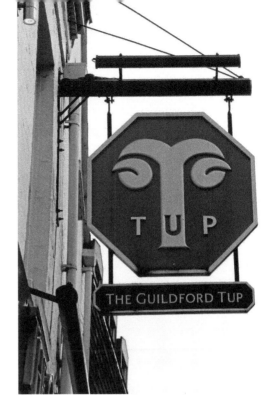

The pub's sign features a stylised ram's head with horns.

pubs once used to billet troops and their horses. The portion of today's pub on the right-hand side was once a small butcher's shop owned by an H. Knight.

It was only in the 1950s that the pub was granted a wine licence – it did not get a full licence until 1961. Owners Courage & Co. lodged plans with the borough council in 1973 to demolish the building and replace it with a block of offices. There was a good deal of opposition to the plans and they were eventually turned down.

Local Journalists Worked up a Thirst Ahead of Press Day

The pub was used by the editorial staff at the *Surrey Advertiser* when their office was in Pannells Court, off Chertsey Street, from the late 1970s until 1999. Rob Searle was a sub-editor on the newspaper at its offices in Martyr Road in the early 1970s. Journalists are well known for enjoying a pint or two, and he recalls, 'We worked late on Wednesdays, until 8 p.m. and sometimes beyond. Thursday was press day and the inside pages of the paper had to be mostly finished the day before. As Wednesday was a long day, we were allowed a half-hour break at 5.30 p.m., our normal knocking-off time. Subbing was thirsty work and we needed liquid refreshment to keep going. Strong tea was just not good enough, so good beer was desired. However, it being many years before all-day opening was allowed, the pubs did not open for the evening session until 6 p.m. so we started our break then. Our usual venue for the break was the Horse & Groom, just up the road in North Street and the purveyor of excellent Courage Best. For a change we went to the nearby Surrey Arms and, if work was slow in coming through from the newsdesk and we could confidently add a few minutes to the break, to the Bull's Head in High Street. We were inevitably the first customers of the evening

and the pub door had often not been unlocked when we arrived. After a couple of pints each, we returned to our desks for a further ninety minutes or so of counting words, checking spellings, correcting grammar and writing headlines. All carried out skilfully and accurately, of course, and I might add that most of us had also imbibed at a local hostelry at lunchtime. The Spread Eagle was preferred for a decent sandwich lunch.'

THE BOILEROOM, Stoke Fields

Much more than a pub, the Boileroom is a music and community arts venue, founded in September 2006 by a dedicated independent group of people led by owner and director Dominique Frazer. She has a background in live music and was previously creative editor of a Guildford-based music magazine called *Spill*. She had been helping to promote live music in venues across the south of England and felt Guildford lacked a decent venue for local artists and those visiting.

As well as its regular live music, the Boileroom welcomes creative people within the Guildford community and a hive of activity goes on under the one roof. This includes its Originate Studios which supports local artists and creative start-up projects. There is a monthly craft club of all ages and abilities, a youth mentoring programme supporting young artists, and a supportive networking group for creative start-up businesses. Then there's SoCiMa Cinema, a not-for-profit social cinema society; Sisters of Surrey, a showcase celebrating women in music from the county; punk rock yoga classes; Surrey SOUP, a micro-funding programme for community groups; and Sunday Assembly Guildford, a secular congregation that celebrates life.

Music and arts feature strongly at the Boileroom.

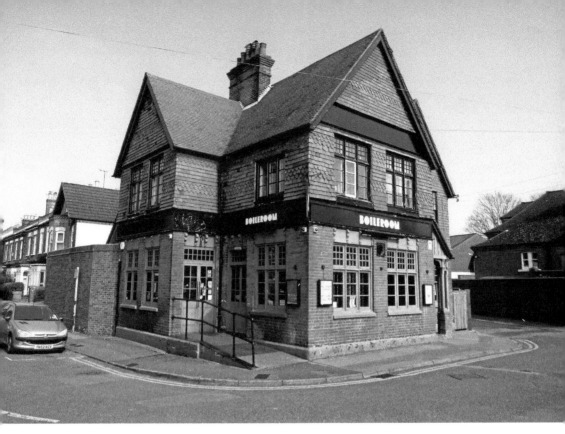

The Boileroom is in Stoke Fields.

Open every day of the week, as well as the venue itself booking musicians to play there, it can also be hired by bands or for corporate launch nights, parties, and so on. Catering can be provided too.

Pub 'Knocked About' by the Great Storm of 1906

The pub's origins go back to 1886 when Guildford's Lascelles, Tickner & Co's Castle Brewery purchased land that was part of Artillery Field. Previously the local militia had used the area for drill practice. When the pub was built and opened in 1887, it took the name the Elm Tree after many trees of that species once being in the vicinity. There was still one elm tree standing beside the pub into the twentieth century. However, on 2 August 1906, Guildford witnessed a terrific storm that claimed two lives and did much damage to property in the town. A newspaper report at the time said the tree by the pub was 'greatly knocked about' and the pub's cellar was so flooded it was unable to serve beer for a while.

THE PRINCE ALBERT, Stoke Road

The Prince Albert is situated just outside the town centre, and when this part of Guildford was being developed in Victorian times they must have had a liking for all things royal! Indeed, there are streets named Kings Road and Queens Road, this pub, and also the King's Head a short distance away (more of later).

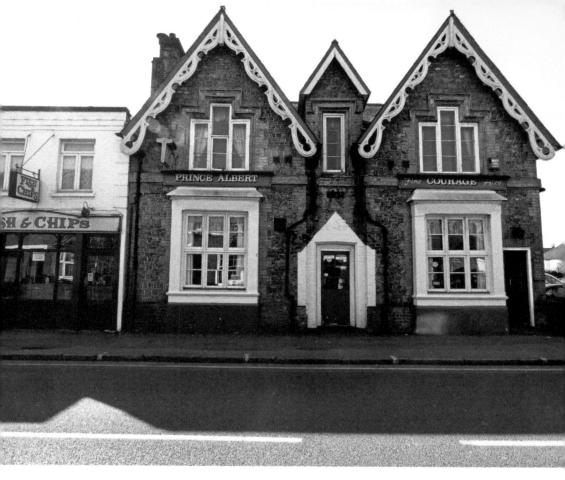

Above: The Prince Albert, Stoke Road.

Left: Always a traditional local – the Prince Albert.

The precise date the Prince Albert was built is a bit of a mystery, but it is listed in old town directories as far back as 1854 as being occupied by a James Hillick. Perhaps he was the first landlord. A James Parson seems to have taken over from 1863 to 1873. He is also listed as 'licensed to let horses'. Perhaps he hired them out, a bit like a car hire firm today.

Hodgsons Kingston Brewery once owned the pub and its records from 1886, when it became a limited company, reveal details of the premises of the Prince Albert pub. Included with the building were a yard, cellars, stables, a pump spring well, cart house, wood house, wash house and other buildings.

Landlord Ran the Fish and Chip Shop Too!

It is also worth mentioning that next door there is a fish and chip shop. It is believed that in around 1913 the then landlord of the pub, a Luke Hebburn, also ran the chippy. But the most well-remembered owners were the Stevens family who served up delicious fish and chips for many years. The fare was so good that it drew people from miles around. It was not uncommon on Saturday evenings to see a queue of people waiting outside for the shop to open. Prices of fried fish were never fixed by owner Roy Stevens; his prices were determined by the price of fresh fish paid for at the market – always fair and of excellent value. The batter he cooked the fish in was also paramount to the taste.

The pub also gets a mention in a story that tells of a fire in 1871 at Stoke Mill in Woking Road. It is said that the volunteers of Guildford fire brigade stopped for a drink at the Prince Albert while on their way to the fire. However, the story is not as it appears. It is believed that the firemen did not simply take the opportunity of having a tipple en route, but most likely called at the pub as they expected to find further volunteers there who they rounded up and took on to tackle the blaze.

Today the Prince Albert retains that traditional pub feel – nothing flash – an honest local. Look out for the decorative coloured lights that usually adorn the exterior at Christmas.

THE STOKE PUB & PIZZERIA, Stoke Road

The pub was once in the parish of Stoke-next-Guildford when it extended along Chertsey Street to a boundary with High Street. It is worth noting that today's borough council ward of Stoke lies on the other side of the A3 and comprises Bellfields and Slyfield. Today the pub is within the ward of Friary & St Nicolas. The name Stoke derives from the Saxon word 'stoc', which simply means a 'place', and probably a defensive one at that.

The pub building has some character, particularly the curiously shaped windows, known as ogee arches. It appears to have been a house and a possible occupant was a James Price. He left £400 to be invested and requested that the revenue generated be distributed to the poor of the parish each year on Christmas Day. He had a nephew (also called James Price) who was born in 1752 and lived elsewhere in the parish, but is known as the 'Alchemist of Stoke'. A story is told that he set up a laboratory and claimed he had found a way to turn base metal into gold and published a pamphlet

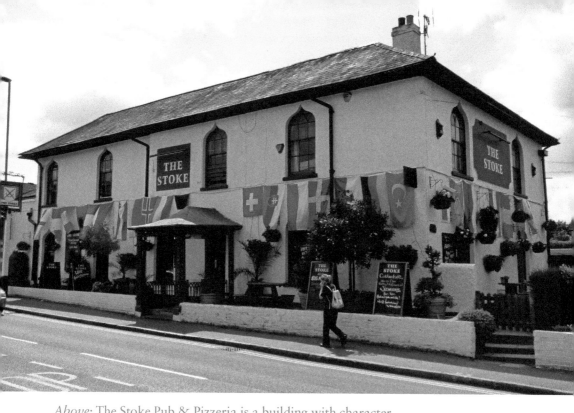

Above: The Stoke Pub & Pizzeria is a building with character.

Below: The pizza oven is behind the bar area at the Stoke.

on his discovery. Three chemists were sent by the Royal Society to check this out and while they were inspecting Price's apparatus, he was either overcome with mercury fumes or swallowed poison and dropped down dead.

Guildford brewer Francis Augustus Crooke purchased the property in 1870 and turned it into a pub. His grandfather, James Crooke, began brewing in the town on a site next to the River Wey (now the car park adjacent to the George Abbot pub) in 1807. When he died in 1834, his son (also James) took over. It later passed to his sons George William and Francis Augustus Crooke. The latter formed the brewery into a limited company and his sons eventually ran it until it went into voluntary liquidation in 1929, at which time it had some thirty-four licensed houses. Some were in nearby villages such as Ripley, Frimley Green and Cranleigh, while there were two as far south as Liphook in Hampshire.

Function Room for All Occasions

For many years it was known as the Stoke Hotel. The function room on the side of the pub continues to be a popular venue that can be hired for wedding receptions, private parties, live music, comedy nights, and so on. At the time of writing, its Friday night live music is hosted by FatCow Promotions. They promise 'weird and wonderful acts' and if you go dressed as a cow you get in free! The function room is also hired out by groups offering zumba fitness classes and various dance classes. First Wednesday of the month sees the You Must Be Stoking live comedy night.

Some may remember when, in the 1990s, it went by the name Finnegan's Wake – a strange move that gave it a kind of Irish theme. It was named after the comical street ballad of the same name popular in the 1850s, a title later used by the Irish writer James Joyce for his novel *Finnegans Wake* (without the apostrophe).

However, as its name today suggests, the pub proudly boasts freshly made pizzas baked in its stone pizza oven, with ten gourmet pizzas on offer, along with a wide range of typical pub grub and Sunday roasts. In early 2016 the pub had a full refurbishment with new interior decor and furniture.

THE KING'S HEAD, Kings Road

Owing to the street in which it is located, the name becomes obvious. The pub's sign takes the form of a postage stamp featuring the head of George VI, but it dates back earlier than his reign, which was from 1937 to 1952. A Stephen Huntley had bought the land on which the King's Head stands for £50 in 1859, and a house was built there soon after. It is known that it was a beerhouse in 1890 when Guildford brewery Lascelles, Tickner & Co. leased the premises for twenty-one years. However, six years later the brewery bought it outright.

For many years it was a Friary, Holroyd & Healy's Brewery (later Friary Meux) house, and has now been under the ownership of London brewer Fuller, Smith & Turner for over twenty years.

When the author was delving into his family's history, he was surprised to find that on his paternal side a great-great-grandfather, great-grandfather and his four children (one being the author's grandmother) had all been resident at the King's Head at the

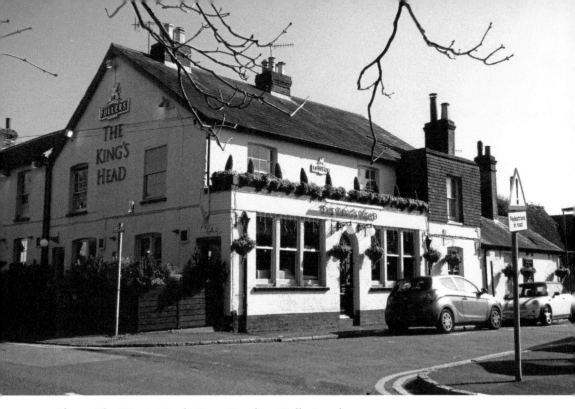

Above: The King's Head, Kings Road – a Fuller's pub.

Below: Small and snug are features of the King's Head.

time of the 1901 census. Their name was Tubbs and it seems they go back a long way in Guildford. Interestingly, on that census they do not appear to have anything to do with the running of the pub, and his great-grandfather listed his profession as a house painter. Other people were also listed, perhaps all lodging there.

Well Discovered when Pub Extended

What is certain is that they wouldn't recognise the pub today. Fuller's has extended the pub, knocking through to an adjoining cottage, which means it is a good deal larger than outside appearances might suggest. Seating areas, some small and snug, surround the bar, while there is a covered courtyard area too. During the building work a well was discovered, and this is now covered by a hatch in the panelled flooring.

Fuller's range of cask ales can be found, along with a changing selection of keg beers from around the world. Add to that a range of Belgian beers of varying strength, bottled beers and lagers, and even beers from Hawaii. These are complemented by wines, liquors and spirits. The food menu changes by the season and is based around British traditional and contemporary fare. There are daily specials and a designated restaurant area if you are after more formal dining.

THE DRUMMOND, Woodbridge Road

Henry Drummond (1786–1860), who the pub was originally named after, was an interesting character. He bought Albury Park mansion and estate in 1819 and set about adding to the house a Gothic tower and sixty-three ornate chimneys designed by famed architect Auguste Pugin. Drummond was a member of parliament and Sheriff of Surrey. He is notable as being one of the founders of a religious movement known as the Catholic Apostolic Church. He built a church in Albury for the movement and a new parish church for local parishioners in 1841, making its original Saxon church, near his mansion, redundant.

While Drummond was still a relatively well-known name, in 1852 Guildford builder James Smith built the pub that bears Drummond's name. He leased it to Thomas Taunton of Guildford's Cannon Brewery. In 1875, it passed to the town's Lascelles, Tickner & Co's Castle Brewery, and later to Friary, Holroyd & Healy's Brewery.

Eventually passing into ownership of Allied Breweries, it closed in 1994. It reopened the following year with new owners, the now defunct Firkin Brewery chain, which had a string of pubs in and around the London area with the novel addition of micro-breweries actually within the pubs – so it became the Forger & Firkin. A shop next door was acquired and this was where the brewing was done. It brewed ales with names such as Sicknote, Dogbolter and Piltdown. Firkin was later bought out and, following a succession of other owners, passed through the hands of Punch Inns and on to Bass. Brewing within the former chain had ceased by March 2001.

The pub simply goes by the name of the Drummond today and trades on its well-kept beers, lagers and ciders, and freshly prepared seasonal pub food. Look out for its 'Tappy Mondays' with £1 off all pints, special deals on wines, or a chance to spice your own Bloody Mary to kick-start your day. There is also a beer garden with heaters.

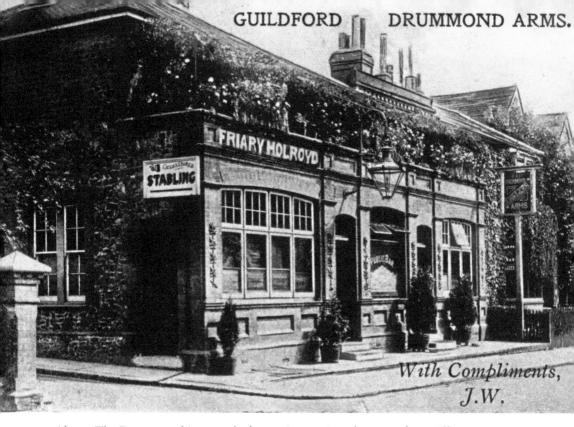

Above: The Drummond is named after an interesting character from Albury.

Below: The Drummond can be found on Woodbridge Road.

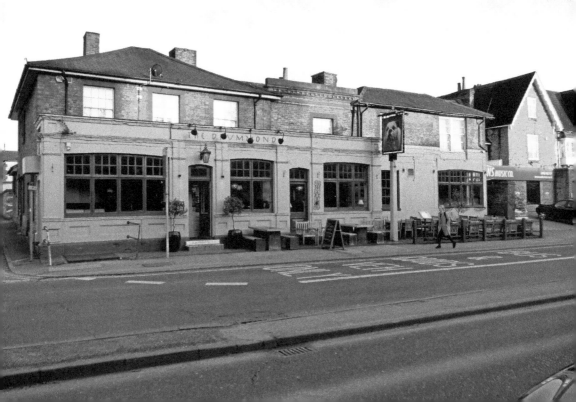

The pub sign you see today features a bulldog. It has nothing to do with Henry Drummond, but a nod to a fictional character called Bulldog Drummond, a gentleman adventurer created by Herman Cyril McNeile. Writing under his pen name Sapper, from 1920 to 1937, McNeile wrote ten novels, four short stories, four stage plays and a screenplay about his made-up prodigy.

YE OLDE SHIP INN, Portsmouth Road, St Catherine's Village
Less than a mile from Guildford town centre, the pub is on the former coaching route from London to Portsmouth, which became a turnpike or toll road in 1749. Therefore it would have been a convenient stop-off point for travellers – and the name must surely reflect all things shipshape found at Portsmouth, where Britain's navy has had a base since 1194.

The pub is a strong contender for the oldest pub still in business in Guildford as it may well date back to the 1550s. It may be imagined that the fashion of changing a pub's name is a new phenomenon, but this one was known at various times in the eighteenth century as the Red Lyon, White Lyon and the King's Arms. However, it has seen a good deal of revelry over the centuries as just along the road on St Catherine's Hill, beside the now ruined chapel, was once an annual fair held each September. At one time it would have been used as a hiring fair, whereby local agricultural workers gathered to offer their services to farmers to secure work for the coming year. In booths

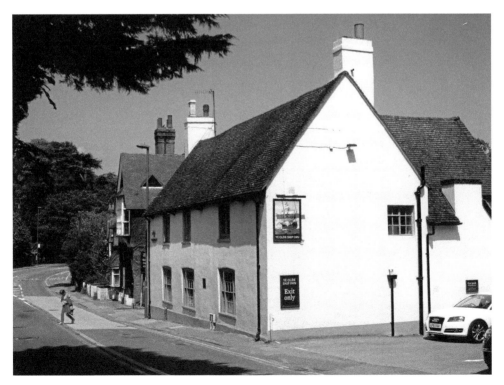

Ye Old Ship Inn is at St Catherine's Village.

Greene King beers are available at Ye Old Ship Inn.

and tents goods were sold and entertainment offered, along with a lot of drinking and merriment. Villagers brewed their own beer to sell and the pub would certainly have cashed in on the annual gathering. The fair continued until 1915, but by then it was mostly a fun fair with the usual coconut shy, 'test your strength' machine and swingboats.

Mystery of a Disappearing Stone Facade

A document dating to 1737 does indeed note the pub as the Ship. In 1886, it was owned by Hodgsons Kingston Brewery and later by Courage & Co. In 1989, it became known as Ships, and later changed to its current name. The facade of the building today, facing the road, is thought to date from the seventeenth century. A stonework front was added in the nineteenth century, which can be seen in early 1900s picture postcards of St Catherine's, but it is unclear when, in the twentieth century, it was removed.

Since 2000 it has been tied to the brewery and pub firm Greene King. Popular with locals and also walkers either following the North Downs Way or the towpath of the River Wey Navigations, it has Cask Marque accreditation and sells a range of Greene King beers, along with those brewed by Morlands, Ruddles, Belhavens and the

Hogs Back Brewery, plus Addlestones cider. On the food front it has a well-deserved reputation for a range of delicious pizzas – baked in a wood-fired oven.

THE ASTOLAT, Old Palace Road

The Onslow Village estate was built by a limited company in the style of a garden city in the 1920s to help with the much-needed housing shortage after the First World War. Initially, some strict conditions were imposed on householders who rented their homes; for example, the hedges surrounding the properties had to be of beech and washing could only be hung out to dry on Mondays. It was also planned to be a 'dry' village – without a pub. Guildford's Friary, Holroyd & Healy's Brewery saw the potential of a pub as near as possible to Onslow Village and in 1933 bought land nearby in Old Palace Road.

However, it took the brewery some time before the pub was built and it duly opened on 10 August 1961. It takes its name from a fifteenth-century book, *Le Morte d'Arthur*, written by Thomas Mallory. He wrote a collection of tales about King Arthur and the Knights of the Round Table. Mallory described how Sir Lancelot, on his way to Camelot (set as Winchester in the book), stops for a night at a town called Astolat and fell in love with a fair maiden. He wrote, 'Now in English it is called Guildford.' Over time this has given rise to some believing that this was Guildford's original name. The story seems to have been rediscovered in the twentieth century as a number of businesses adopted the name, such as the Astolat Tea Rooms situated in the High Street and the Astolat Garden Centre that was at Peasmarsh, and, of course, this pub.

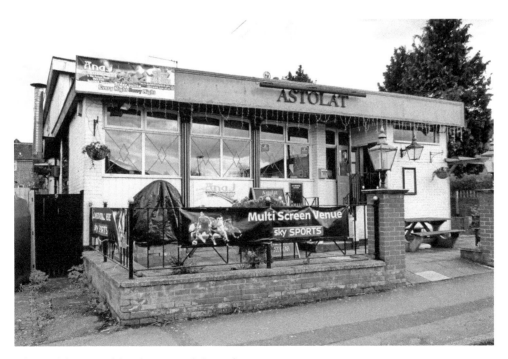

The Astolat on Old Palace Road dates from 1961.

'Astolat', the name given to Guildford in an ancient book.

When Blues Music Went Down a Storm

A previous landlord for several years was Richard Spall (brother of the famous actor of stage, TV and screen, Timothy Spall). Originally hailing from Battersea in London, Richard hosted live music at the Astolat. Blues was a specialty and the Sunday evening sessions drew large crowds. Back in the late 1980s, the author played there regularly as the singer with his band Sammy Rat's Big Big Blues Band.

Today, it is independently run and is a welcoming locals' pub, with a pool table, dartboard, and plenty of live football on the TV. Beers include Hogs Back Brewery TEA, Sharp's Doom Bar, Guinness, Carling, Coors Light, Fosters and Grolsch. It is also the location of Anji, an Indian takeaway. You can order online via Just Eat and they'll deliver to your door.

THE ROW BARGE, Riverside, Bellfields

There is some local history relating to the brewing process on the site of this riverside pub on the edge of Bellfields estate. A map of the River Wey Navigation dating back to 1823 shows a building named Smallpeice, and this was at one time a malthouse. Someone of that name is likely to have founded it.

This was a building where barley was turned into malt, a product which contains complex carbohydrates and sugars necessary for fermentation – a key ingredient in brewing beer. The three-stage process is the same today: barley is soaked in water and then allowed to germinate. At just the right time germination is halted and it is dried, becoming malt. Malthouses need to be fairly large to complete the process as floor space is needed to spread out the barley.

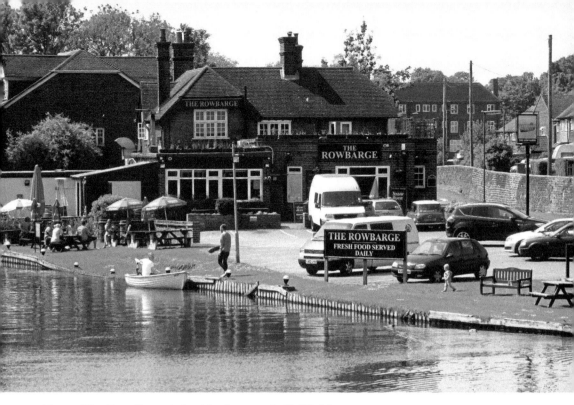

Above: The Row Barge is beside the river in Bellfields.

Below: Live music is a feature of the Row Barge.

From a Maltings to a Beer Shop

Only sketchy recorded evidence exists of how long this malthouse was in existence, but by the time of the 1841 census it was listed as Malthouse Row, then occupied mainly by agricultural workers and their families. So perhaps it had ceased to be used as a maltings. On the 1851 census two families are listed, the Bakers and the Mills, and written by the name of the latter are the words 'Row Barge'. Perhaps part of the building was being used a beer shop by then.

Nothing of the building exists today, but the pub, its car park and grass area beyond occupy the site where it once stood. A clue to the date when the current pub was built was noted in details when acquired by Guildford's F. A. Crooke & Co. in 1909. A document states it had recently been rebuilt. There was also once a pair of timber-clad cottages where the car park is, but they were pulled down many years ago after a fire. In the early 1900s rowing boats could be hired from here.

The Surrey and Hampshire Borders branch of the Campaign for Real Ale (CAMRA) named it pub of the year for 2012, and today the pub is run by the leaseholders of the Guildford Tup in Chertsey Street. They have had the tenancy of the Row Barge since 2013 and it remains a pub used by locals as well as boaters on the river who can moor up beside it. It continues to sell real ales by Ascot Ales, Dartmoor Brewery, St Austell Brewery and Surrey Hills Brewery. It has two bars, one being a pool room, there's live music and jam nights, plus sport is shown on the big screen TV. Food, including Sunday roasts, is also available.

WOODEN BRIDGE, Woodbridge Hill

Some may wonder why such a large roadhouse-style pub was built here with today's A3 dual-carriageway separated from it by a large wooden fence. It was, of course, once right on the A322 leading into Guildford from a northerly direction and beside the Guildford and Godalming bypass. It was a popular stop for coaches taking people to and from the coast. Traffic congestion is nothing new in Guildford and back in the 1950s local people actually gathered by the roadside here on summer evenings to watch the long columns of coaches and those in cars making their way home.

The bypass was opened in 1934, and with housing being built on Woodbridge Hill and in Westborough, plus motor manufacturers Dennis Bros' factory nearby, this was an ideal site for a new and large pub. It bears the date 1936, which is when it opened and was licensed to Farnham United Breweries.

It is well known (locally anyway) for several appearances there by the Rolling Stones before they became famous. This was in 1963 when two young live music promoters, Philip Hayward and John Mansfield, opened a music venue in Windsor under the name Ricky Tick. They then hired other venues in Guildford, Reading and Croydon to put on bands, one of them being the Wooden Bridge. They were known as Ricky Tick Clubs and they played host to the best of the then up-and-coming blues, rock 'n' roll, jazz and rhythm and blues bands.

The Stones played the Ricky Tick Club at the Wooden Bridge on 9 and 30 March, 19 April, 17 May, 7 and 22 June, and 2 August 1963. The gig on 7 June is notable as on that day they had a single released on the Decca label, with *Come On*, written by

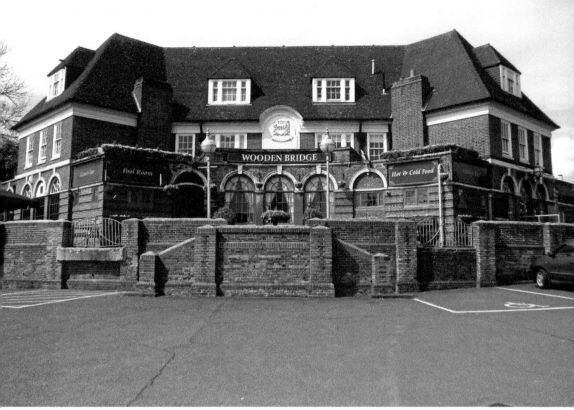

Above: The Wooden Bridge was opened in 1936.

Right: The Rolling Stones played at 'the Bridge' several times.

Chuck Berry, as the A side, and *I Want To Be Loved*, written by Willie Dixon, on the B side. Fame was just around the corner and the band embarked on their first UK tour during September and October 1963, that included a date at Guildford Odeon on 14 October, returning on 15 December. They never played the Wooden Bridge again!

Having a Drink with Mick Jagger at 'the Bridge'

Memories of people who witnessed the first night the Stones played at the Wooden Bridge recall it being noisy with fans stomping their feet and waving their hands. Fire doors were ripped open and those fans who had been locked out when the pub became full suddenly surged in. However, Pete Phillips tells a different story. He saw the Stones at the Wooden Bridge several times and says the first time there were only around fifty people there and before the band played he had a drink and a chat with Mick Jagger about each other's love of American music.

The Wooden Bridge continues to host live music to this day, while football on the big screen also draws the punters in. It is now owned by the John Barras Pub Co. and offers, beers, wines, spirits and cocktails. The food is typical pub fare, and is reasonably priced.

HOLROYD ARMS, Aldershot Road

The family from which the pub takes its name were brewers from Byfleet. At the beginning of the twentieth century, George Barron Holroyd was the managing director

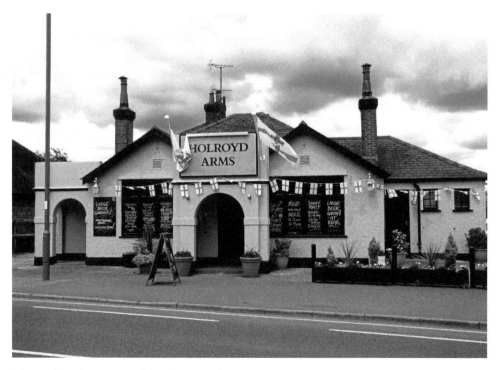

The Holroyd Arms in Aldershot Road.

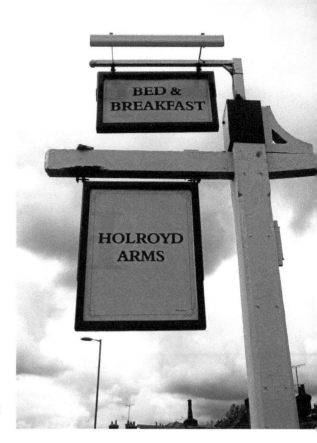

'A good old British pub' is the Holroyd Arms.

of Guildford's Friary, Holroyd & Healy's Brewery. He lived at Byfleet and was the chairman of its district and parish council.

However, it seems the building had been occupied in around 1910 by Woodbridge Hill Workingmen's Club. It had a bowling green there and the author's maternal grandfather was one of the club's founder members and a keen bowls player.

The club sold up within around a decade and moved into new and larger premises on the opposite side of Aldershot Road (with a bowling green to the rear). In 1924, Friary, Holroyd & Healy's Brewery bought the building and reopened it as a pub. Its licence was transferred from a pub that had closed, the Malt House Tap that was in Portsmouth Road.

Mind the Goldfish Bowl Hanging from the Ceiling!

In and around the 1980s the Holroyd Arms featured a very large glass goldfish bowl that was hung from the ceiling in the bar area to the rear of the pub. The lights were often dimmed and the fish bowl was an obstacle that needed to be carefully avoided when carrying drinks back to where you were sitting.

Today the Holroyd Arms describes itself as a 'good old British pub' as well as being a café and an entertainment venue. It features a pool table, table football and three dartboards, and live sport is shown on plasma screens. The pub plays host to live bands and disco nights. From 10 a.m. Monday to Saturday it is open as a café and full English breakfasts can be ordered.

Pubs in the Villages of the Borough of Guildford

THE WHITE HART, Wood Street Village

The White Hart is one of the most common pub names in England. A white hart, or mature stag, was the personal heraldic badge of Richard II and there is an interesting local connection here. A royal deer park was created in Guildford around 1154 which covered roughly the area occupied by today's University of Surrey, Onslow Village, Westborough, Park Barn and Woodbridge Hill. It was one of thirteen such parks within what was called Windsor Great Forest. For several centuries royalty came to Guildford to hunt, but unfortunately it is not known whether Richard II came here.

Wood Street Village was just to the edge of Guildford's royal deer park, but this pub has some history too. The building is thought to have been a blacksmith's shop in the eighteenth century, and a beer shop from the middle of the nineteenth century. A William Hammond was running it in 1861, and although he had died by 1871, records show that his widow, Susan, continued as beer shopkeeper and grocer. Guildford brewer Thomas Taunton had been the leaseholder of the pub. In 1874 it was acquired by Charles Hoskins Master of the Friary Brewery and remained in its ownership for many years as a typical village pub with hardly any changes to the building, fittings and fabric. Like so many pubs it also supplied off-sales. There was a small hatch with a sliding window to the side of the building. A customer would tap on the window and it would be opened, usually by a little old lady, who dispensed bottles of beer, or if you had brought your own mug, filled it for you.

Pub Transformed into Freehouse

The old pub changed in 1981 when a trader from Farnham, John Martin, bought it and it became a freehouse not tied to any particular brewery. The interior was transformed and anyone stepping in there for the first time since the changes got quite

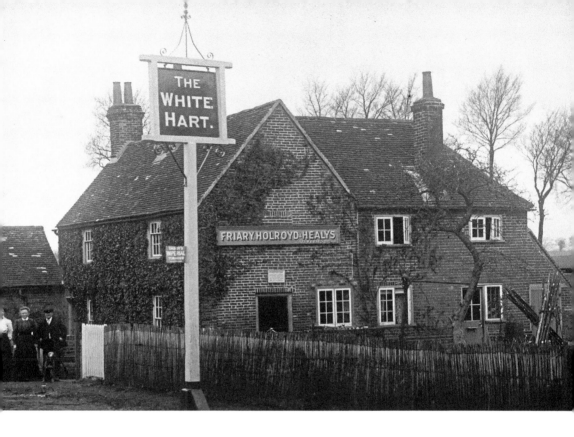

Above: The White Hart as it looked in around 1900.

Below: The White Hart – full of beams and character.

a shock. Above the bar was an oval-shaped block of wood upon which was written 'Good 'ere init!' Mr Martin, dressed in a sharp suit and slicked-back grey hair, stood at the bar welcoming customers as his staff scurried around serving the drinks. Soon it became packed with a much younger clientele who came from far and wide.

There were other alterations, notably an enlarged car park while the adjacent barn was turned into a restaurant. John Martin later sold the pub to the Wiltshire Brewery. In more recent times the pub has had further facelifts and owners and is now very much a gastropub owned by MLC Pubs that operates other licensed houses in Berkshire and Oxfordshire. In 2014, the White Hart won a certificate of excellence from travel website TripAdvisor.

THE JOLLY FARMER, Burdenshott Road, Whitmoor Common, Worplesdon

With Whitmoor Common on its doorstep, the Jolly Farmer is a good place to visit after a walk in the local countryside. Its origins are that it was once a simple beerhouse without a licence to sell any other kind of intoxicating liquor. And it must have been somewhat remote, with its regulars being those who lived in a scattering of cottages on the common.

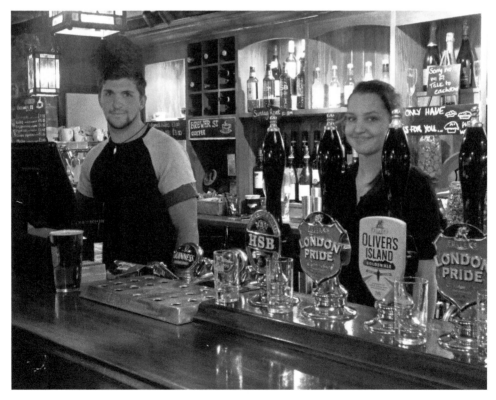

Bar staff at the Jolly Farmer, Burdenshot Road.

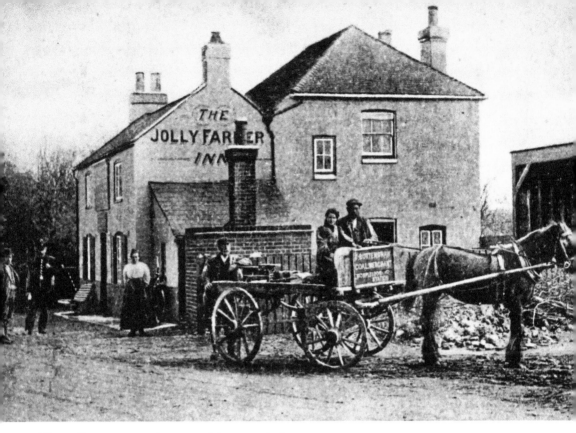

The Jolly Farmer at the turn of the twentieth century.

The name Whitmoor probably comes from 'white moor' as the poor sandy soil here is almost white. Locals once eked out a living grazing cattle, sheep and pigs, removing wood for building materials and fuel, while sand and stone were extracted to mend roads and paths. Consequently, the land was much more open than it is today. During the past forty-odd years the trees have grown back, and although undeniably attractive to those who live here today and those who enjoy visiting, the landscape is much different.

The common supports a wealth of wildlife. A cuckoo can often be heard in springtime, while as night falls during the early summer months the strange *churring* sound of nocturnal nightjars is heard.

Publican and Coal Merchant

Guildford brewer Thomas Lascelles acquired the pub as far back as 1852, and by the early 1900s the publican was a J. Burtenshaw, who had a second business as a coal merchant. The coal yard was next to the pub and near the railway line that passes close by. When the author visited the pub recently, the manager said that a few weeks before some people dropped by and told her they were descendants of the Burtenshaw family.

The Jolly Farmer is a Fuller's pub today and is both cosy and tastefully decorated inside. It also has an enclosed garden with plenty of space for alfresco dining. There

are themed nights and gourmet food and wine evenings, while the food on the menu is sourced locally and changes with the seasons. The menu includes main meals, snacks and sandwiches, plus a children's menu. A full range of Fuller's beers is on tap.

THE WHITE LYON & DRAGON, Perry Hill, Worplesdon

Standing at the top of Perry Hill, one of the four villages in the parish of Worplesdon, the building was completed in 1940 and named the New Inn. It might seem strange that the large roadhouse-style pub was built, firstly at a time of austerity during the Second World War, and secondly for what purpose, as the community was, and still is, not particularly large?

It is likely that plans for the building were passed and work had begun before the war had started, and its then owners, Courage & Co., saw potential from the increasing motor-coach trade on the busy A322 Bagshot road, as they did a few miles south with the Wooden Bridge pub at the foot of Woodbridge Hill.

There was an earlier pub called the White Lyon at Perry Hill which stood roughly where the car park of today's pub and restaurant is. It dated back to the late seventeenth century and was among a group of buildings that included a blacksmith's forge, complete with the village stocks in front. In 1718 its name was changed to the New Inn.

When Guildford brewery W. E. Elkins sold it in 1847, among the features listed were a parlour, taproom, dairy, pantry, kitchen, five chambers approached by two staircases, yard with knife-house, well and a good garden. The Friary Brewery leased it in 1870, while by 1924 it was a tied house of Farnham United Breweries.

A 1900s' view showing the previous White Lyon pub.

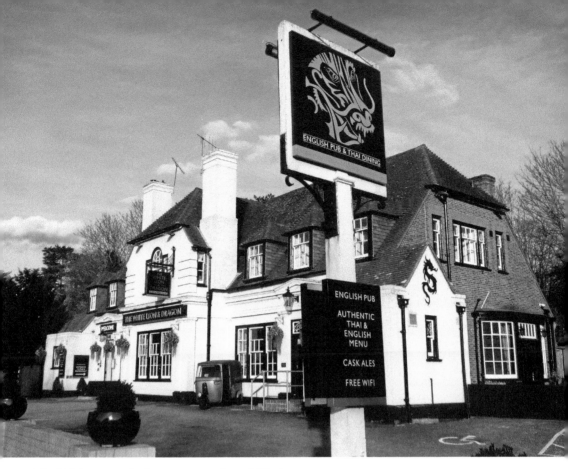

The White Lyon & Dragon – a pub and Thai restaurant.

Pub's Fortunes Revived by Live Music, 1980

Twenty-five years after the new New Inn was built, at the landlord's suggestion, it was changed to the name of the earlier White Lyon. In the following years, and as the coach trade dwindled, it was a kind of two-thirds empty, locals-only pub. Publicans came and went, and trade was hardly brisk. For several years in the late 1980s tenants Keith and Julie Sanderson did a lot to revive the pub. It was known for having occasional live music, but the Sandersons used the large saloon bar to its full potential and the pub built up a good reputation with audiences flocking to the bluesy rock bands who played there.

The pub's fortunes have been turned around again as it is now both a pub and a Thai restaurant. The space inside comprises an attractive and cosy pub area in what was once the public bar, and a stylish restaurant decorated in an Eastern style in the former saloon bar.

THE BLACK BISON, Aldershot Road, Rydes Hill

The curious name reflects the pub offering bison meat on its food menu. Evidently, the red meat is low in fat, high in protein and rich in flavour. It's also easier to digest by people who have a degree of red meat intolerance.

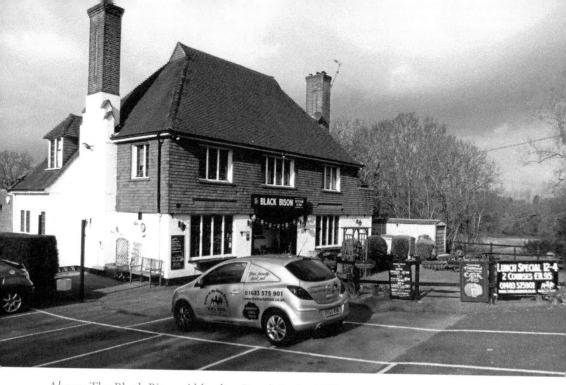

Above: The Black Bison, Aldershot Road, Rydes Hill.

Below: The fireplace with its interesting cast-iron sign.

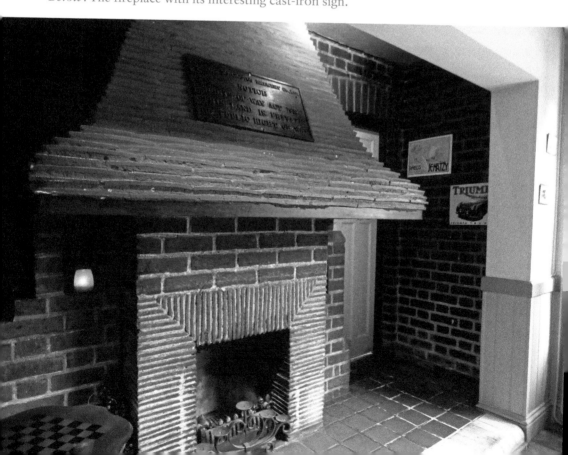

With new owners, it has recently changed its name from the Cricketers and has had a fresh makeover. The layout remains much the same with the main bar area as you enter and a separate dining area further in. It also has seating outside at the front and in the garden to the rear.

Of the former name, it's doubtful whether cricket was played on the common land to the side. However, in his youth the author and his mates did play football there, using coats and jumpers to mark the goals, and a funfair used to pitch up from time to time.

The origin of the area Rydes Hill is thought to be derived from Rede's Hill – perhaps someone of that name once lived thereabouts. Today's Rydes Hill Preparatory School, further along the Aldershot Road towards Guildford, was once a private house. Previous occupants were members of the Elkins family, who were brewers in Guildford. They rented it for a few years from 1851.

There was a building on the site of the Black Bison at that time as records state in 1855 it was occupied by a Charles Scotcher, and it may well have been a pub by then. With the name of the Cricketers it had gained a full licence by 1904 and was then owned by Guildford's F. A. Crooke's brewery. Taken over by Hodgsons Kingston Brewery in 1929, a new building was constructed in the 1930s.

Design of Pub in Arts & Crafts Style

With its steep tiled roof and two tall chimneys, it looks as if its design was inspired by the Arts & Crafts movement. Many of the features when built survive, such as a lovely half-circle of red floor tiles in front of the porch, itself framed by sturdy timber beams, and two red-brick and tile fireplaces. Nicely polished floorboards throughout, along with the furniture, complement the overall building's design.

For those who like a bit of brewery miscellany, on the fireplace to the right-hand side of the pub (near the gents' loos) there is a cast-iron sign which reads, 'HODGSONS KINGSTON BREWERY CO., LTD / NOTICE / RIGHTS OF WAY ACT 1932 / THIS LAND IS PRIVATE / NO PUBLIC RIGHT-OF-WAY.' So, be warned: you should only enter if you intend to sample its range of beers and other drinks or to enjoy its food!

THE WHITE HART, The Green, Pirbright

The one-time Manor of Pirbright owned a property called Lane End House, which was built sometime during the seventeenth century. After passing through various owners, it came into the possession of a Lawrence Porter in 1781 and he turned it into the White Hart public house.

Back in medieval times part of the local area had been a royal deer park, similar to the one to the west of Guildford and noted previously with the other White Hart, at Wood Street Village. Once again, this pub's name may reflect this. The name Pirbright is said to derive from the words *pyrign fyrhth* – meaning where pear trees grow within space in a woodland.

The area was sparsely populated when the White Hart first served up ale and hospitality, with one or two fairly large homes with gardens and a sprinkling of labourers' cottages. The heathland and its poor soil has never been good

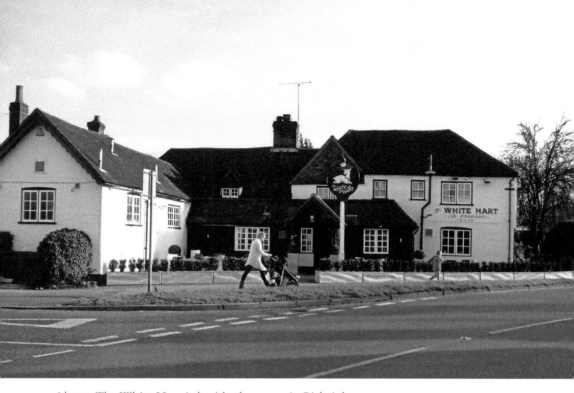

Above: The White Hart is beside the green in Pirbright.

Below: Called the Moorhen briefly, it's now the White Hart again.

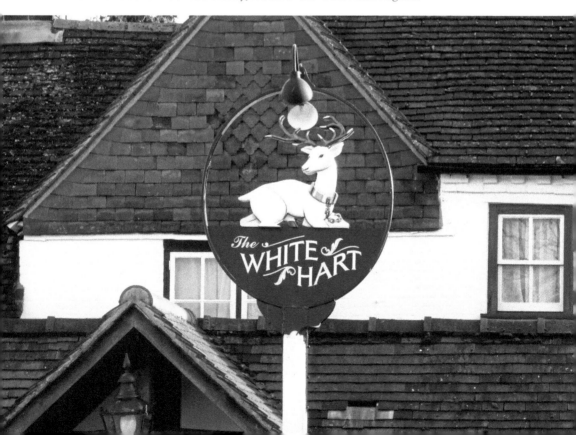

farmland. In the early 1800s the pub was in the ownership of a William Belsher Parfitt, who was a brewer from Eversley in Hampshire, with a couple of dozen pubs spread through parts of Hampshire, Berkshire and Surrey. By 1856 it had been bought by Guildford brewer Thomas Taunton and was later acquired by the Friary Brewery.

The White Hart remained a typical village pub for many years – with the standard public and saloon bars (as did most pubs). It is, of course, only in more recent times that pubs have been drastically altered and turned into one-bar establishments with perhaps a separate restaurant area.

Villagers' Successful Protest after Name Change

The ubiquitous trend for changing pub names in recent times backfired when it was applied to the White Hart. It became the Moorhen, but this did not go down well in Pirbright, despite the nearby pond on the green being a haven for ducks and other wildlife. The villagers protested and to make their point erected a sign on the edge of the green at the road junction opposite the pub that read, 'White Hart Corner'. It did the trick and the original name was reinstated.

It is tastefully decorated inside and affords a smart appearance outside, with brickwork painted white complementing the black of its timber-clad entrance. It is one of Mitchells & Butlers Leisure Retail Ltd's public houses. 'Freshly cooked pub food and a broad range of quaffable wines and real ales' is how it advertises itself.

ANCHOR & HORSESHOES, London Road, Burpham

Sited on the former main road from London to Portsmouth, the horseshoe part of the name is a clue to a previous business here, namely a blacksmith's shop; the anchor was a familiar pub sign along a road that led to the coast. Where the two cottages stand next to the pub there was indeed a blacksmith's shop. In days gone by they were variously known as Horseshoes Cottages and Anchor Cottages.

Parts of the building date back to the seventeenth century, while recent research by local historian Moria MacQuaide Hall has revealed that a George Heath was probably a publican here as early as 1785. Later his son James took over, and it just so happens that they were also the blacksmiths!

Over the years the pub has also been called the Anchor, the Horseshoes, and Horseshoes & Anchor; for example, on a map of the Wey Navigation from 1823 it is named as the Anchor and Horseshoes, while in a document relating to a tithe map of 1839, it is noted as the Horseshoes Inn, with its owner and occupant being a William Baker. He had married Lois Heath, sister of James Heath.

It appears to have then had several owners and by 1889 the pub had been leased to Guildford's Lascelles, Tickner & Co's Castle Brewery. In 1909, a William Baker (the son of William and Lois Baker) sold the pub to Farnham United Breweries. Later acquired by Courage & Co., the pub was extended in 1968.

Aircraft Crash Lands in Garden

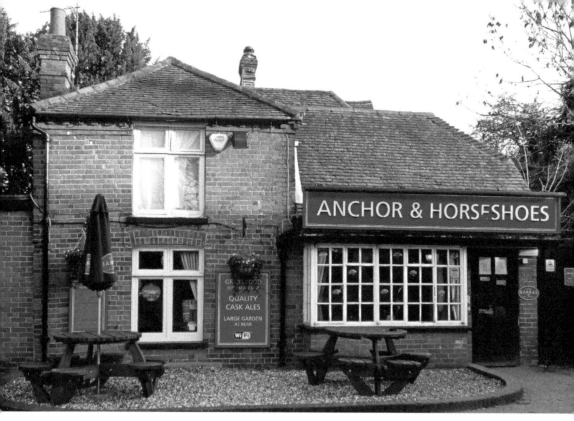

Above: The Anchor & Horseshoes is in Burpham.

Below: The pub has a pay and display car park.

On 10 January 1954, the then landlord, Robert Lintott, heard a terrific bang and went outside to see a light aircraft that had crash-landed in the pub garden. Shortly afterwards he told the local press, 'The plane landed on the hedge and rose pergola, about fifteen yards from the back of the house.' It was indeed a near miss and thankfully the Miles Gemini aircraft's two occupants suffered only minor injuries. The pilot, journalist Ken Owen, had flown from Leeds and was heading towards Fairoaks airfield near Chobham. With light fading, he had circled Burpham looking for a place to land and had identified a field beyond the pub, now part of George Abbot School. As the aircraft descended its starboard wing clipped a row of oak trees spinning it through 360 degrees before coming to rest.

Today, the Anchor & Horseshoes is part of the John Barras Pub Co. chain. It promotes it as a local pub with friendly service along with a wide range of pub food and drink at great prices, and they also pride themselves on their Barras range of burgers. It is somewhat unusual in that it has its own pay and display car park.

THE HORSE & GROOM, Epsom Road, Merrow

There was once a racecourse on Merrow Downs and a previous name of the pub was the Running Horse. It is therefore not surprising it has a connection with the sport of kings. There is no trace of the racecourse today, but it was where Guildford Golf Club is now. It was roughly oval shaped and at right angles to today's Trodds Lane. As the

A sign on the Horse & Groom may not be accurate.

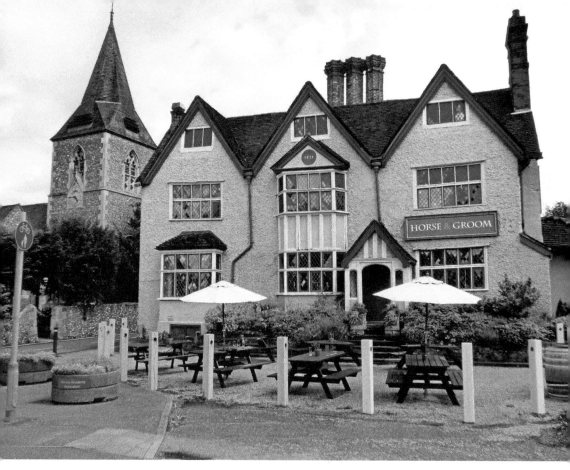

The Horse & Groom in Merrow was originally a farmhouse.

horses raced around the course they would have crossed the road in two places. Races were held there from around 1701 to 1870.

Race meetings were usually held at Whitsuntide. Large crowds gathered and there was a wooden grandstand, believed to have been erected at the western end of the course's home straight. The racecourse attracted royal patronage and the King's Plate prize was worth 100 guineas at a meeting held on 24 July 1838. Competition from Epsom and Ascot racecourses led to the decline of the course at Merrow.

Originally Built as a Farmhouse

The Horse & Groom pub has a date on it that reads 1615. It is unknown whether this is the exact date of its construction, but the likelihood is that this attractive timber-framed building was originally a farmhouse and dates from sometime during the seventeenth century. A picture by James Pollard painted in 1830 does not show the date on the building. Existing title deeds go back to 1778, when it was bought by a victualler by the name of Benjamin Ward from the Onslow family of Clandon Park. Ward had been the sitting tenant, and at the time it was called the Hare and Hounds. It became the Running Horse sometime during the first part of the nineteenth century when owned by a Thomas Gibbens. His widow sold it in 1863 to a brewery from

Reigate, Mellersh & Neale, and at that time it had been named the Horse and Groom. The brewery carried out renovations and perhaps the date on the front was added at that time.

While the exterior of the pub has remained much the same in its appearance, apart from the repainting of the woodwork and the rendering on the walls, inside it has been extensively refurbished several times over the past thirty-odd years. Today it is a Mitchells & Butlers Leisure Retail Ltd house, and note the pub's name now takes an ampersand. At the time of writing, the Horse & Groom's range of beers included lagers from around the world and craft beers from London, Cornwall and Edinburgh. A long list of wines, spirits and cocktails is also available to enjoy in an agreeable interior that cleverly blends traditional-rustic and modern furniture and decor. Food is definitely gastropub in style and there are separate menus for lunch and dinner.

THE BULL'S HEAD, The Street, West Clandon

It's not known when the Bull's Head first became a pub, but the building certainly dates back to the sixteenth century and was built as a timber-framed hall house. Alterations and extensions were added at times during the three centuries that followed. However, there was a victualler by the name of Richard Holte who had an alehouse in the village in around 1576, and it may have been his premises.

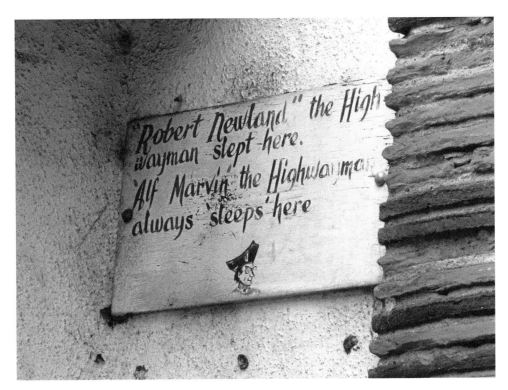

A sign that refers to a previous landlord.

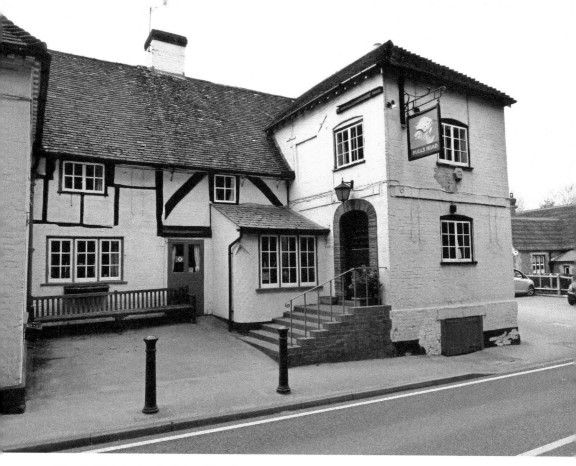

The Bull's Head is in West Clandon.

There is a record of a dinner held at the Bull's Head in 1810 for members of the Court Barons of Clandon, so it must have been a licensed house by then, and it is noted on the 1839 tithe map of West Clandon as in the ownership of Guildford brewer James Crooke, with the occupant being a John Rogers.

It's likely the Crooke family made alterations and added a cellar and a self-contained cottage. At one time there were also stables and outbuildings, where the pub's car park is now. When it was bought by Hodgsons Kingston Brewery in 1930, among details listing the property was the adjoining Bull's Cottage, formerly Kemp's Cottage, and another known as Bull's Head Yard Cottage.

Publican Alf Marvin, A Colouful Character

The licensee around the 1970s and '80s was Alf Marvin. A well-known local landlord who had previously been at the King's Head in Ash. While there in 1964 he was filmed in colour by British Pathé, the company that made newsreels and short films usually shown in cinemas. Alf was featured dressed as a matador and is seen pitching his skills against a ram in the pub garden – it can be viewed on Pathé's website.

Back to the Bull's Head: village carpenter Alfred Day's memories are featured in a book, *The Clandons: A Look Into The Past* (published in 1991). He recalled that

games played at the pub included bagatelle, dominoes and shove halfpenny. The game tippit, which originated in Wales and was played with a coin, was only allowed to be played at the Bull's Head on Sundays. He also noted that pubs were open from 6 a.m. to 10 p.m. and 'good beer was 2*d* a pint, spirits 2*d* and 3*d* a tot'.

This must have been before the First World War as in 1915 pub opening times were restricted from noon to 2.30 p.m. and 6.30 p.m. to 9.30 p.m. The legislation was passed to keep people fit for working long hours and to satisfy the government's fears over excessive drinking of alcohol.

Today the Bull's Head offers all that is good about a traditional English pub, with real ales including the Surrey Hills Brewery's Shere Drop, along with a wide selection of food during lunchtimes and evenings including its own home-made pies.

THE KING WILLIAM IV, The Street, West Horsley

Known locally as the 'King Billy' this village pub offers gastro-style food. It was originally a pair of cottages dating back to Georgian times. In the early nineteenth century they were bought by a miller named Edmund Collins who moved in with his family. He is thought to have added the lean-to on the north side and used it to brew his own beer. Thus in 1830 he turned the two front rooms into the King William IV Beer Shop. His windmill was at Windmill Hill, off the Shere Road.

He may well have chosen to name his beer shop after the then reigning monarch and a nod to the fact that in 1830, the year William IV came to the throne, an Act of Parliament

The King William IV is in West Horsley.

The King William IV once brewed its own beer.

was passed making it easier for people to open beer shops without having to obtain a full licence. This was done to encourage people to drink beer and to curb the spiralling and harmful consumption of cheap spirits – gin being the demon drink at the time.

The Licensee Was A Local Entrepreneur

Edmund Collins must have had a great entrepreneurial spirit as he opened a second beer shop in the village, which he called the Red Lion. He also owned the village bakery and a malthouse, thus being rather self-sufficient in making his own raw materials for his business ventures. He died in 1866 and his son-in-law, George Richardson, took over the beer shop. At some time around the middle of the nineteenth century, it obtained a full licence and remained in the ownership of generations of the same family until 1987.

An extension to the pub was added in 1905, and this was used as a games room and for serving teas to weekend cyclists.

Today it is a popular stopping-off point for walkers and ramblers enjoying the many footpaths through the Surrey Hills, villages and local National Trust properties. Its selection of real ales and good food has earned it a listing in the AA's book, *Britain's Best Pubs*. There are food-themed evenings, live music and events with a barbecue in the pub's garden.

THE DRUMMOND AT ALBURY, The Street, Albury

The pub and restaurant, which also offers accommodation with nine bedrooms, is not owned by one of the large pub chains but is instead part of the Albury Estate owned by the Duke of Northumberland. The estate, which covers around 150 acres, passed into the ownership of the 6th Duke of Northumberland in 1890 after the death of his wife Louisa. She was the daughter of Henry Drummond of Albury Park, whose achievements are noted in the previously featured pub the Drummond, in Woodbridge Road.

Alnwick Castle in Northumberland is the ancestral home of the Dukes of Northumberland, whose family name is Percy. They also own a good deal of land (some 100,000 acres) in that part of England. Long before they came to have an interest in Albury, there was a pub in Weston Street called the Running Horse dating back to the eighteenth century. Henry Drummond bought it in 1822 and the landlord at the time was a William Baker. The pub was rebuilt in 1830 and renamed the Drummond Arms.

The pub once had its own brewery on site and in 1877 the beer was being brewed by a James Potter. From 1870 to 1904 the leaseholder was a John Beet. He advertised 'genuine bitter and family ale brewed from the finest malt and hops', along with 'excellent stabling and accommodation for cyclists at moderate terms'.

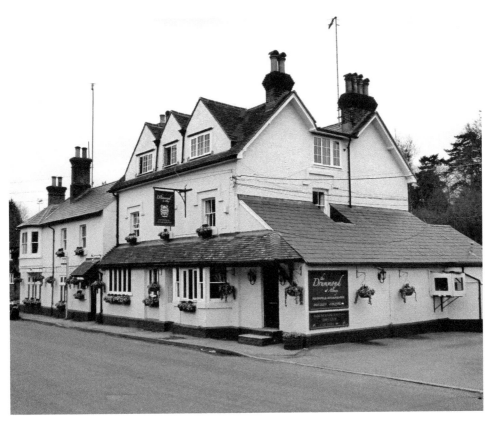

The Drummond at Albury, owned by the Duke of Northumberland.

The Drummond has a popular restaurant and pub garden.

Dukes of Northumberland Retake Control

In 1910, the Drummond Arms was leased to the Surrey Public House Trust that had been formed in 1901 and which ran a number of pubs in the local area. It converted the old brewery into dining rooms that appear to have been is use as a restaurant ever since. At some point the Dukes of Northumberland took back control, and in more recent times have periodically refurbished the pub accordingly. In 1989, £250,000 was spent on it and it received another makeover a few years ago.

Four real ales are usually on offer with wines, spirits and soft drinks. It is popular with locals, visitors and hotel residents alike, relaxing in its cosy bar with an adjoining conservatory. The restaurant, which serves gastropub food, is situated to the left-hand side, complete with tasteful decor. The garden is popular when the weather is fine and extends to the Tillingbourne Stream that flows by, complete with ducks.

THE WHITE HORSE, Shere Lane, Shere

The village of Shere has often been described as the prettiest in Surrey, and it certainly is attractive with its old church, character buildings and the Tillingbourne Stream running through the centre of it. Added to this is the White Horse pub, looking resplendent with its black timber frames and white walls. The building is believed to date back to around 1500 and was originally a farmhouse.

Above: The White Horse, owned by pub company Chef & Brewer.

Below: The White Horse pictured in the early twentieth century.

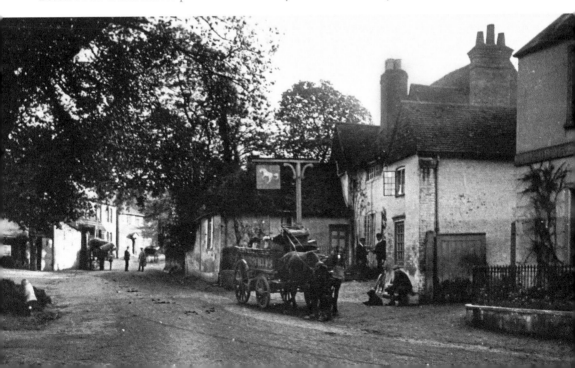

It became an inn during the seventeenth century and from 1664 to 1730 was kept by a family called Sherlock. They added a cellar and a separate brewhouse, while on adjacent land there was a hop garden. It had attained a full licence sometime before 1869 and was owned by Savill's Brewery of Shalford. Brewers Watney, Combe, Reid & Co. Ltd acquired it in 1923, and it was only then, during alterations, that the timber framing on the front of the pub was added. So, first impressions as to age can sometimes be deceptive! It has also been claimed that some of the pub's timbers came from HMS *Victory*.

In 1955 a hidden cellar was discovered with a number of casks of brandy, some of which were dated 1720. It prompted some to say these must have been stored there by smugglers. The theory was probably based on those tales of gangs of men bringing contraband from overseas up from the Sussex coast using the network of sunken lanes and pathways through the Surrey countryside to designated drop-off points, all in the hope of avoiding an encounter with excise men or local night-watchmen.

Smuggling Brandy and Secret Hiding Places

Noted garden designer Gertrude Jekyll, in her book *Old West Surrey* (first published in 1904), wrote about the smugglers' exploits. She noted, 'The smugglers travelled at night, keeping to the woods and heaths and least frequented lanes.' Miss Jekyll added that contraband was sometimes hidden 'among the thickets of juniper, thorn and bramble'. She claimed, 'When the country people discovered the hiding-place of contraband goods, it was customary for the finder to put a chalk mark on a small proportion of the number of articles. When the smugglers went again to collect their kegs [brandy], the marked ones were left. This was understood as a bargain, in consideration of the discovery not being reported.'

Other finds during renovation work include old parchment documents and a pair of shoes, thought to date back to Elizabethan times, that may have been hidden as a good luck charm.

The White Horse is now owned by Chef & Brewer, a company that focuses on tradition in its pub restaurants. It offers lunch and evening menus and also a children's menu.

WILLIAM IV, Little London, Albury Heath

Everything about the William IV ticks the boxes of what a good traditional country pub should be – stone floors, rustic wooden furniture, an inglenook fireplace, real ales, honest grub, and surrounded by acres of woods and heathland that are great for walkers.

Locals, sitting or standing around the small bar, along with those exploring the countryside, complete with muddy boots and perhaps their pet dogs, are the usual types to be found here. Fresh home-cooked food made from local produce is offered, sometimes including pork that the pub's owner, Giles Madge, has raised himself. Ales from local micro-breweries are stocked, so it comes as no surprise that it has been listed in the Campaign for Real Ale's (CAMRA) *Good Beer Guide*.

Parts of the building may date as far back as the sixteenth century when it was a house. For around a hundred years (up until 1929) it was owned by members of a

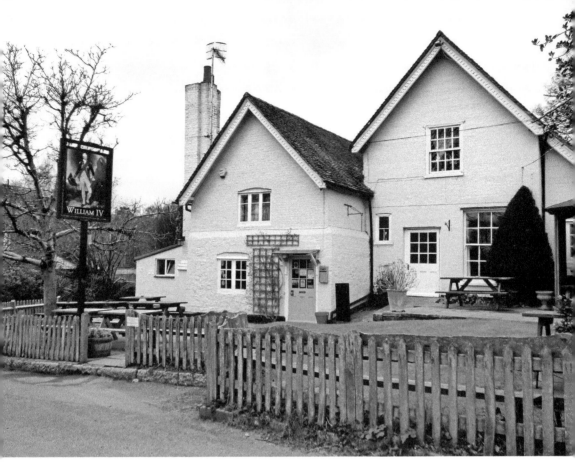

Above: The William IV, Little London, Albury Heath.

Below: A sign at the pub about riding and hunting stables.

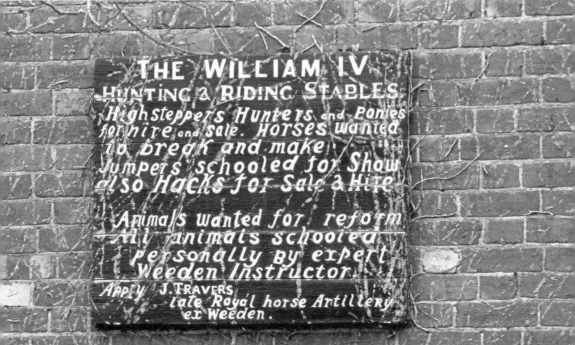

family called Mercer, and may well have become a beerhouse around the 1850s. They eventually sold it to Farnham United Breweries. In 1976 its then owners, Courage & Co., sold it to Michael and Linda Short, and, with various owners, it has been a freehouse ever since. Back in the 1980s there was blackboard on the wall above the urinal in the outside gents. Suffice to say, the graffiti written upon it was quite an interesting read when relieving oneself!

Area Teemed with Canadian Troops During Second World War

During the Second World War thousands of Canadian troops were stationed throughout the south of England to defend Britain should Germany launch an invasion. Troops lived in temporary camps along the North Downs and the Greensand Ridge, including the area around Albury. Many of them were later to take part in the Normandy landings. In May 1944, shortly before D-Day, General Bernard Montgomery addressed more than 1,000 soldiers on Albury Heath. He told them that they would be under his command for the landings. The site where this took place is marked by a cairn with a plaque. It was unveiled in 1984 by local resident Win Browne, who had watched the events of 1944. One wonders how many soldiers enjoyed a pint in the nearby William IV pub.

THE SEAHORSE, The Street, Shalford

Had events of the Second World War been different, and Hitler had ordered an invasion of Britain, the line of the North Downs would most likely have seen fierce fighting as our defence force faced the German Army. Supposing the Germans had landed on the south coast and had fought their way towards London, gaps in the hills such as at Guildford and its villages may well have been one of the last lines of natural defences before the capital.

In the summer of 1940, defences were quickly constructed in a line across southern England and from the Thames estuary to the Wash. Known as the GHQ Stopline, it consisted of concrete pillboxes, roadblocks, tank traps, ditches and so on.

What has this got to do with the Seahorse pub? Next to it, and in front of the pub garden, are the remains of a concrete roadblock set into the wall. Had the unthinkable actually occurred, who knows what may have happened, as men bravely fought to save Britain.

The pub itself was fortified with loopholes cut into the upstairs rooms and facing the road. An anti-tank ditch was dug from nearby Dagley Lane which went right through the pub garden and the yard where big concrete blocks had been positioned. There is no trace of the ditch or the blocks today.

The Seahorse became a pub in the 1740s and had previously been a property called Burtons. Records indicate that it had actually been two adjoining cottages and in the early nineteenth century was knocked into one. The Guildford brewer Crooke's leased the pub in 1811 and by 1869 it had a full licence. When Crooke's brewery closed in 1929, and its pubs sold off, The Seahorse was bought by brewers George Gale & Co. of Horndean, Hampshire.

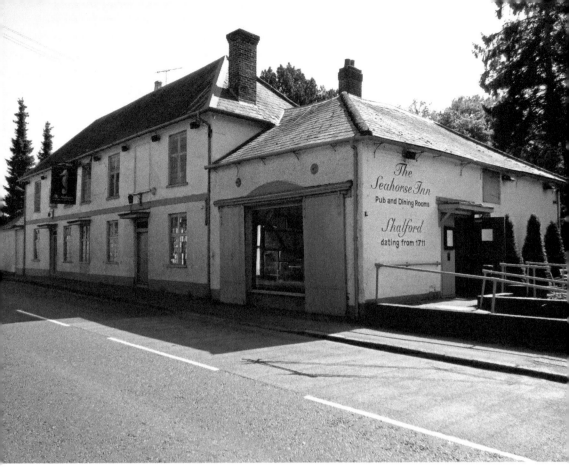

Above: The Seahorse is owned by Mitchells & Butlers.

Right: Concrete remains of a wartime roadblock at the Seahorse.

Landlord Sang Theme Tune from Andy Pandy at Closing Time

The landlord in around the 1970s and '80s was a character called Tony. A genial gent, he had a novel way of encouraging his customers to drink up when he called time. Without fail, using a microphone he sang the words that were heard at the end of the once-famous children's TV programme *Andy Pandy*: 'Time to go home, time to go home … Andy is waving goodbye, goodbye.'

The pub received alterations and extensions as well as improvements to its car park in 1992. One feature added was a painted picture of an old woman looking out from an upstairs window. It was rather ghostly in appearance and some people complained. It must have breached planning regulations, as the Guildford Borough Council quickly ruled that it be removed.

Today, the Seahorse is a popular pub-restaurant run by Mitchells & Butlers Leisure Retail Ltd. It offers a wine club where members can enjoy special discounts and receive news and details on new wines as they are introduced. The pub chain features beers and lagers from around the world as well as local brews.

THE QUEEN VICTORIA, Station Row, Shalford

Shalford's affinity with Queen Victoria goes further than a pub bearing her name. Close by, and on the edge of the village green known as 'the common', is a granite drinking fountain and cattle trough. It was erected by local people to celebrate the Diamond Jubilee of Queen Victoria in 1897. On jubilee day itself (20 June), flags and

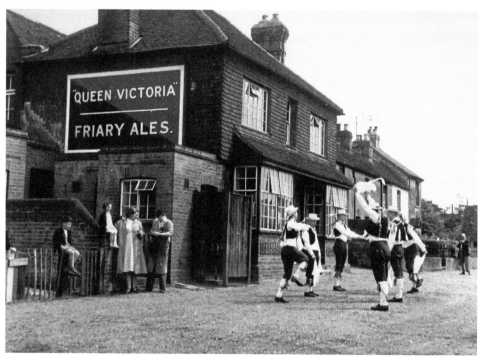

Morris dancers at the Queen Victoria, from around the 1950s.

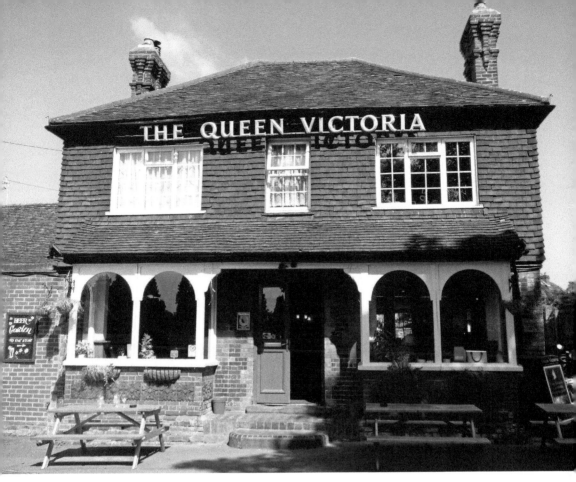

The Queen Victoria is in the village of Shalford.

bunting decorated the village. Older residents were treated to a lunch at the village hall and in the evening a bonfire was lit on nearby Chinthurst Hill.

The pub building dates back to the early nineteenth century, when two messuages, or dwelling houses, were built by a Charles Richardson. In 1814, he sold them on and later one became a pub – assumed to have been after Victoria came to the throne in 1837. It had been leased to Thomas Bosville Baverstock of Godalming's Sun Brewery, until acquired by Guildford's Castle Brewery in 1855.

Wartime Train Collision and Blaze

There is also a Second World War connection to this pub. On 11 April 1944, two goods trains collided in nearby Shalford railway station. This was during the build-up to D-Day on 6 June, and one of the trains consisted of tankers full of aviation fuel being taken to a destination in Kent. A number of the derailed wagons by the road bridge at the entrance to the station were leaking fuel. A huge blaze erupted with flames shooting high into the air. Thanks to valiant work by men of the National Fire Service, the blaze was contained. Their efforts were helped by local policemen and members of the Home Guard who used sandbags to stem the flow of burning fuel.

Property nearby was damaged by the blaze, including a store owned by a potato and vegetable merchant. Part of the steel road bridge was buckled by the heat, but the Queen Victoria pub escaped unharmed.

Currently, the Queen Victoria is a family-run pub and is popular with locals and visitors alike. Definitely an honest pub in the traditional style, rather than a restaurant that also serves beer, it does offer lunch and evening meals, ranging from burgers, fish and chips and Pieminister pies, to sausage and mash, hunter's chicken and salads, and of course Sunday roasts. There is a range of real ales and cask beers, with live music and open-mic nights too.

THE ANCHOR, High Street, Ripley

The Anchor was once known as 'a Mecca of all good cyclists'. This was in the nineteenth century when literally hundreds of them descended on Ripley every weekend, many from London, using the open roads and exploring the countryside. Once at their destination they'd enjoy lunch or afternoon tea and the Anchor was a favourite of theirs.

It was once an almshouse that dated back to the sixteenth century until a new poorhouse was built in the village in 1738. A Robert Whitburn, a brewer from Ripley, bought the building in 1821 for £320. He was declared bankrupt in 1834 and the property was sold.

By the 1870s, cycling had become a popular pastime and the then landlady of the Anchor, Harriet Dibble, catered for the pedal pushers in style. She was a widow with

The Anchor, once 'a Mecca of all good cyclists'.

The Anchor is in Ripley's High Street.

seven children and ran the pub with two of her daughters, Annie and Harriet. The pub served lunch at two shillings for up to 400 cyclists each Sunday. It also offered accommodation for weary travellers.

In 1881, the Dibbles started to collect the signatures of their visitors and it was in 1887, when Lord Bury cycled to Ripley, that he wrote the 'Mecca' phrase. Up until 1895 fourteen volumes were filled with cyclists' names and their comments, and some included famous people such as the writer H. G. Wells and John Dennis, one of the founders of Guildford motor manufacturers Dennis Bros.

Mrs Dibble died in 1887, followed by her daughters Annie and Harriet in 1895 and 1896, respectively. The pub was then taken over by son Alf. However, it was not long before the cycling craze began to wane as motor transport took over.

Saga of the Historic Visitors' Books

The visitors' books remained in the pub, although in 2002 it was discovered that two were missing. Then, six of the books were put up for auction and sold to a wealthy Arab. Fearing the remaining books might also disappear, cycling historian and local resident Les Bowerman stepped in and paid £6,000 to rescue them. A campaign was launched to raise money in order to pay Mr Bowerman back and to deposit them at

the Surrey History Centre. The money flooded in and in 2004 the books were duly handed over.

The Surrey History Centre now has photocopies of the six books that had been bought at auction, but the whereabouts of the other two are still unknown.

Now a freehold pub, bought by the owners of Ripley's Drakes restaurant in 2013, the Anchor can choose which beers it serves. At the time of writing, Timothy Taylor is its signature ale, while it also offers locally brewed beers from the Tillingbourne and Frensham breweries. The owners offer Drake's versions of pub food, with ingredients produced both locally and regionally.

THE TALBOT HOTEL, High Street, Ripley

With its fine brick frontage dating from the eighteenth century, the Talbot Hotel has welcomed travellers and locals alike for centuries. The name is that of a white hunting dog, a breed that is now extinct. The exact age of the inn is not clear, but some parts may date to around 1450, although most of the building is thought to date from the sixteenth century and is of a timber-frame construction.

There were some unlawful goings on at the Talbot in 1636 when the innkeeper, a Richard Staunton, was fined two shillings and sixpence for 'holding and permitting illicit games'. Unfortunately, the record does not state what they were.

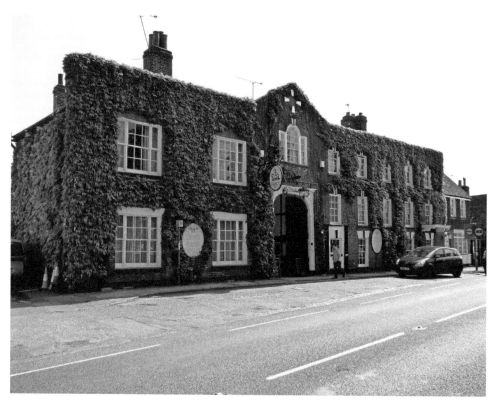

The Talbot Hotel is a pub and restaurant.

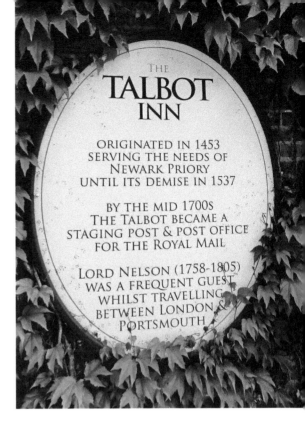

A sign of the times at the Talbot Hotel.

The inn benefited when sections of the road between London and Portsmouth were turnpiked after an Act of Parliament in 1749. Roads were improved and tolls charged for those using them. Stagecoaches became more commonplace, their golden age being between 1800 and 1830. The Talbot was a staging post for the coaches and their horses. By 1769 the inn had become a post office receiving office with the Royal Mail coach pulling in.

Did Lord Nelson's Love affair Blossom Here?

It goes without saying that the Talbot must have welcomed Royal Navy personnel as they made their way to and from Portsmouth, but the stories that have evolved about the love affair between Lord Nelson and Emma Hamilton blossoming there in 1798 may just be fantasy, as is a supposed connection with the eighteenth-century highwayman Claude Duval.

Two wealthy local landowners, Lord King, Baron of Ockham, and the Earl of Lovelace, from Horsley Towers, both owned the inn separately, with the latter first leasing it and then selling it to Ashby's Cobham Brewery in 1893. It then passed through the hands of a number of owners during the twentieth century, and in April 2014 it was announced in the catering press that the management of the Talbot Hotel had been taken over by Jupiter Inns.

On the menu is a 'Lord Nelson Burger', and why not? The hotel also offers rooms for private dining, special events and conferences. Some of these also reflect the 'Nelson connection', with names such 'The Victory Room' and another called 'Emma's'.

THE WITHIES, Withies Lane, Compton

Past writers have often noted the beauty of Compton. Eric Parker, in his book *Highways & Byways In Surrey* (first published in 1908), wrote,

> Compton looks like a village presided over by a single mind. The cottages which add themselves to whatever is old in neighbouring buildings are designed to fit in with the scheme; the cottage gardens are challenges of roses and phloxes, which shall be brightest.

And Graham Collyer writing in *The Surrey Village Book* (first published in 1984) commented:

> Of the twenty-five parishes in England which bear the name Compton, probably there is not one which can surpass Compton in Surrey.

The Withies is situated just off the busy main road through the village, yet Compton is certainly worth a look around rather than simply driving through to another destination. The church of St Nicholas has a unique double sanctuary and the oldest piece of Norman woodwork in the country. Nearby is the revived Watts Gallery Artists' Village, where paintings and sculptures by George Frederick Watts (1817–1904), who was known as 'England's Michelangelo', can be seen along with work by other artists, described as 'a unique Arts & Crafts gem nestled in the Surrey Hills'. A visit is not complete without also viewing the nearby Grade I-listed red-brick Watts Chapel. There's even a couple of shops in Compton selling antiques and collectables.

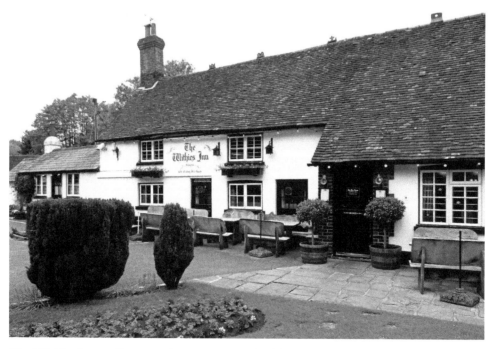

The Withies Inn at Compton is an attractive building.

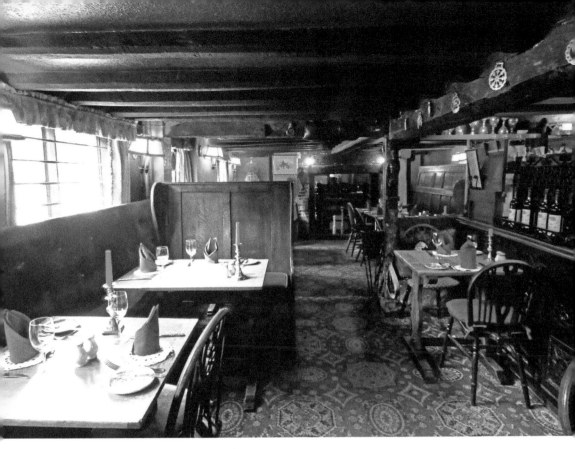

Mind the low beams inside the Withies!

Delightful Building with Original Wooden Beams

Then perhaps a visit to the Withies? A warm welcome awaits whether you are enjoying a drink or having a meal. The building is a delight, dating back several hundred years. It was acquired by a Reuben Smith in around 1827 who converted it first into two cottages and then later into a pub called the Withy Tree. The name was inspired by pollarded willows nearby, a tree whose slim branches are known for use in basket-making.

Once a tied house of Guildford's Friary Meux brewery, it was sold to Withies Inns Ltd in 1974 and became a freehouse – and so it still is today. Now tastefully modernised, retaining the charming wooden beams and period features inside, a drink and a meal can be enjoyed in the garden too, weather permitting.

The Withies once had a reputation of being somewhat exclusive. This may have been due to the alleged story that American singer and actor Bing Crosby was once refused admission as he was not wearing the 'correct attire'!

THE GOOD INTENT, The Street, Puttenham

Hops, that staple ingredient of beer, are still grown here in Puttenham. A 14-acre site on the south-facing slope of the Hog's Back are planted with a traditional variety known as Fuggles. The hop garden is managed by the Hampton Estate, based at nearby Seale.

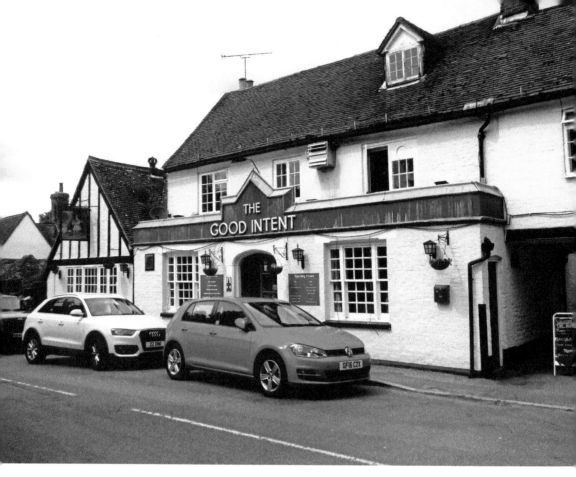

Above: The Good Intent can be found in Puttenham.

Left: Hops are still grown near the Good Intent pub.

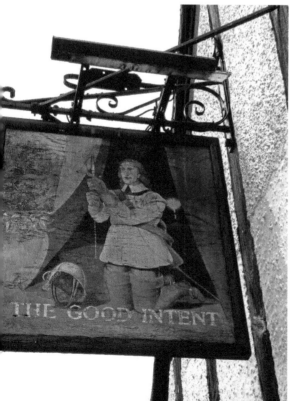

The hop plants begin growing in April and are trained in the time-honoured way on vertical strings held up by posts, otherwise known as hop poles. They are harvested in early September, then dried before being packed into 85-kilogram bags. They are sold to several brewers including the Hogs Back Brewery just 'over the hill' at Tongham. The brewery itself has now begun to grow its own hops to supplement its production. Its hop garden covers a 3.5-acre site adjacent to the brewery.

Go back a couple of hundred years and this whole area close to Farnham would have been filled with hop gardens. It's encouraging that the tradition not only continues, but is now expanding.

The Good Intent pub is not as old as hop growing in the area. The building may date to the eighteenth century or earlier and once belonged to the Manor of Puttenham Priory. The first known reference to it as being a licensed house is in 1870. The tenant, a Henry Marshall, who had been there since 1863, handed it over to the Guildford brewery owned by the Crooke family.

Home Guard in Pub as Incendiary Bombs Falls

During the Second World War incendiary bombs, dropped by the Germans, landed in the gardens of Puttenham Priory. Its occupant, Lady Harcourt, was dining at the time (as always in evening dress) and went outside with her butler to see the bombs hanging and burning in some trees. She instructed him to put out the fires, so he went to look for men of the local Home Guard only to find them drinking in the Good Intent. He rounded them up and they duly dealt with the incident.

Today the pub is well known for stocking a good range of real ales along with lagers, ciders, wines, and so on. It usually holds a mini beer festival over the bank holiday at the end of May. Traditional pub fare is on the menu, along with toasted ciabattas, sandwiches, jacket potatoes, ploughman's and basket meals.

Just after midday on 5 April 2016, an outbuilding next to the pub, used for accommodation and storage, caught alight. The pub was evacuated and thankfully no one was injured. Although the outbuilding was destroyed, firefighters prevented the blaze from spreading to the pub itself. Amazingly, the pub was back open and serving drinks later that afternoon.

THE LION BREWERY, Guildford Road, Ash

The publican of the Lion Brewery is Mike Armitage, who has been running it for more than thirty-five years. In a story published in the *Morning Advertiser* (the newspaper for the pub trade) in 2015, Mike said the success of his pub had been due to his close relationship with his customers.

In the same article he added that the pub tries to accommodate as many as possible and they listen to what their customers want. Perhaps that is the secret of its popularity.

A number of social groups and societies, including pigeon-racing clubs, sports, music and a couple of angling clubs take advantage of using the pub's function room that is let out at no cost. It is also available for hire for weddings and parties, and so on.

Above: The Lion Brewery, Guildford Road, Ash.

Left: The Lion Brewery hosts a good deal of live music.

Music Festival Raises Funds for Charity

However, the Lion Brewery is also renowned for its live music with mainly rock cover bands every Friday and Saturday nights, jazz on Sunday nights and jam sessions on Tuesday and Thursday nights. Mike Armitage and his wife Lyndsey also organise the Ash Music Festival, held annually on the last Saturday in July on Harper's Recreation Ground adjacent to the pub. Money generated by the festival is donated to cancer charities and over the past thirty-five years the pub and the festival have raised £250,000.

Of the history of the pub, it most likely takes its name from either the Lion Brewery or the Red Lion Brewery (or both) that were trading in Farnham at the same time. In 1889 they merged to become Farnham United Breweries. Another suggestion is that yet another Lion Brewery, one that was sited at Lambeth in London, may have lent its name to the pub.

Previously the pub was called the Mount Pleasant Beerhouse. In 1861 a Robert Waters had a beerhouse and a bakery there. By 1871 the beerhouse was being run by his daughters Rosanna and Alice. Rosanna married a George Fountain and they then ran it between them. It may well have been in their time that the pub was renamed the Lion Brewery.

THE GREYHOUND, Ash Street, Ash

The name of the village is associated with the ash tree as opposed to the powdery residue left when something is burned, while the pub's name may have something to

The Greyhound is beside a busy roundabout in Ash.

The Greyhound is run by the Stonegate pub firm.

do with a family called Gaynesford who, in the fifteenth century, owned Poyle Manor in Tongham. Their coat of arms featured three greyhounds and Gaynesford was once a nickname meaning a 'happy or light-spirited person'.

The pub stands near the county boundary with Hampshire and faces the town of Aldershot. The growth of Ash and Ash Vale is linked to that of Aldershot – dubbed 'the home of the British Army'. A military camp was established on the barren heathland there in 1854, and by 1914 was the largest army camp in the country. As the area developed, many pubs were built to cash in on the thirst of army personnel. More than 120 pubs alone are known to have been opened in Aldershot, while in the parish of Ash, there were, by 1861, sixteen pubs.

The Only Pub in Ash

However, the Greyhound predates the coming of the military to the area and at one time was the only pub in Ash. It originally looked out over a small green where village fairs were held, but the green disappeared to make way for road widening in 1956.

The Greyhound is mentioned in a document dating back to 1795 in which a Richard Lymposs of Guildford appointed a Joseph Pannell 'at the Greyhound, Ash' as an overseer of his will. The name Lymposs is known in Guildford as a family who once had a forge in today's Upper High Street and who were also dairymen. It is recorded that in 1826 a Thomas Thompson was the tenant at the Greyhound, while the occupant in 1855 was a William Fountain. Perhaps he was a relative of George Fountain, mentioned previously in connection with the Lion Brewery pub.

The pub once had its own brewhouse, noted when the pub was acquired by the Lion Brewery of Lambeth in 1861. Four years later it leased it to Guildford brewers Thomas and Silas Taunton, but by the end of the nineteenth century it was in the hands of Guildford's Friary Brewery.

The tile-hung frontage that the pub has today may look as if it has some age, but was only added in the 1930s. Further alterations that included turning the former stable yard into a car park were undertaken in 1991.

It is now run by the Stonegate pub company which operates more than 660 pubs throughout the UK from its headquarters in Luton, Bedfordshire. The Greyhound offers a wide range of food throughout the day with seasonal and special offers. Beers are sourced from around the country and also change each season.

THE SWAN, Hutton Road, Ash Vale

There are always lots of interesting features along Britain's canal network – locks, bridges and of course pubs! The Swan can be found beside the Basingstoke Canal as it weaves its way from its junction with the River Wey Navigation at Byfleet, past Woking, Pirbright, Ash and Ash Vale and then deep into Hampshire.

The Basingstoke Canal was opened in 1794 with the aim of supporting and developing agriculture in central Hampshire. It cost £154,463 to build (twice the estimated cost) and was something of a financial disaster, as by 1866 no dividends had been paid to its shareholders. The original canal company was declared bankrupt, but it continued to operate. The last commercial load on this stretch was 10 tons of sand conveyed from Mytchett to Basingstoke in 1910.

However, some parts of the canal were used in later years, notably by the army in and around Aldershot during the First World War, while coal and timber were delivered to Woking up until around 1947. By 1966 it had become overgrown and abandoned.

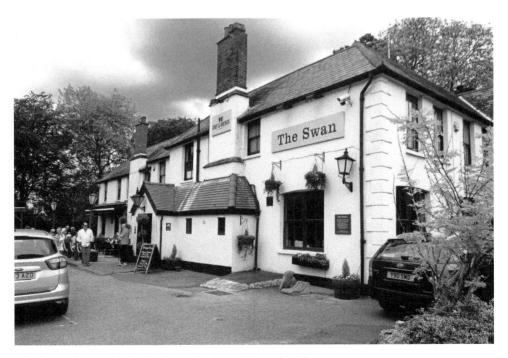

The Swan is beside the Basingstoke Canal in Ash Vale.

The Swan also has a large pub garden.

Restoring the Basingstoke Canal

In 1966 the Surrey and Hampshire Canal Society was formed with the aim of securing public ownership of the waterway and restoring it. During the next seventeen years both Surrey and Hampshire County Councils funded a restoration project with the help of the canal society and the Inland Waterways Association. The canal was formally reopened by the Duke of Kent at Frimley on 10 May 1991. Now looked after by a number of local authorities and stakeholders, it is a wonderful recreational amenity as well as a haven for wildlife. Whether you walk or cycle along the towpath, or travel by boat, a stop-off at the Swan is a likely port of call.

The pub owes its origin to a John Tupper, who purchased the site on which it stands in 1857. Indeed, the Tupper family ran it until 1928, and during that time it was known as 'Tuppers', although a map of 1871 shows it as 'the Swan'. Back then, certain 'sports', such as prizefighting and cockfights, took place at the pub, and it also had a rat pit. The latter was a blood sport that involved placing rats in an enclosure which people would then bet on, guessing how long it would take a dog to kill them. These sports are now banned. In 1904 the Swan was recorded as having a full licence and could 'sleep two' with stabling for 'ten' [horses] and was 'patronised by the military and labouring class'.

The Chef & Brewer pub chain runs the Swan today. It was refurbished in a contemporary style in 2006 and the emphasis is now on pub food with regular meal deals and offers. Alfresco dining can be enjoyed in the pub garden beside the canal.

THE WHITE HART, The Street, Tongham

Nestling close to the north-facing dip slope of the North Downs (known here as the Hog's Back), Tongham has been inhabited since Neolithic times. From the thirteenth to the sixteenth century it was called Twangham, although the White Hart pub only dates to the seventeenth century.

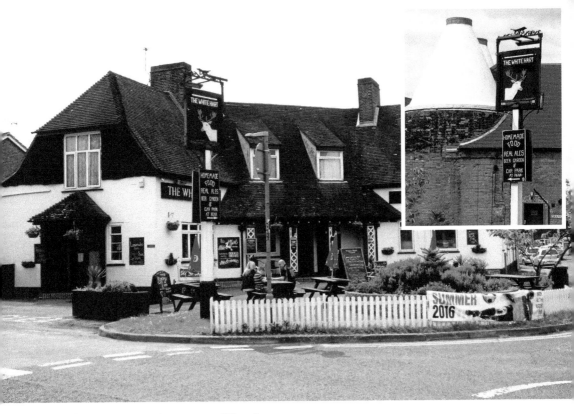

The White Hart is in the centre of Tongham.
Inset: Opposite the White Hart are some former oast houses (hop kilns).

Crooke's brewery in Guildford owned it during the nineteenth century, and in 1929 it became a licensed house of Hodgsons Kingston Brewery. The pub was rebuilt in 1939 and was later owned by Courage & Co.

Near the pub is a pair of oast houses that have now been converted into homes. These are a reminder of the area once rich in hop-growing, as mentioned previously. Nearby is the Hogs Back Brewery – the producer of a number of award-winning ales. The brewery opened in 1992 in a group of eighteenth-century farm buildings. The first ale brewed was its now signature TEA – Traditional English Ale, which can now be found in many pubs within the Guildford area and beyond, and in major supermarkets. The family-owned brewery has prospered and now includes other delights such as RipSnorter, Hazy Hog Cider and Hogstar Lager, to name but a few.

Annual Beer Festival, September

Naturally, the White Hart offers beers from its neighbouring brewery, as well as ales from the Surrey Hills, Triple FFF, Ascot Ales, Courage and Fuller's breweries, and more. It hosts a beer festival each September and offers a range of regular events that include live music and DJs, a quiz night on Tuesdays and a meat raffle on the first Sunday of the month. Food is served at lunchtimes and during the evenings. The pub describes its fare as a 'modern spin on traditional pub food', with it being 'all homemade with fresh ingredients and using local produce'. Daily specials are offered along with a menu for children.

Bibliography

This book would not have been possible without the detailed research into the history of Guildford's pubs and breweries by the late Mark Sturley. He did this over a period of twenty years and the results he published in two books that head this bibliography.

Sturley, Mark, *The Breweries and Public Houses of Guildford*, (Guildford: Charles W. Traylen, 1990)

Sturley, Mark, *The Breweries and Public Houses of Guildford Part Two* (Mark Sturley, 1995)

Dugmore, Ruth, *Puttenham Under the Hog's Back* (Phillimore, 1972)

Pubs: An Historical Pub Crawl In Words And Pictures (Send & Ripley History Society, 1998)

Clark, Lyn, *Stoke Next Guildford A Short History* (Phillmore, 1999)

Bowley, Pam, *Old West Horsley The Story Of A Surrey Village* (Horse & Tree Publications, 2000)

Palmer, P. G, *Pubs of Aldershot Across Three Centuries* (Aldershot Historical & Archaeological Society with CLIO Publishing, 2004)

Gould, Veronica, *Compton Surrey* (Arrow Press, 1990)

Various research by the author, some of which has been published in a number of his previous books and articles and on the online news website *The Guildford Dragon NEWS*.

Other information from the pubs visited and their websites was correct at the time of writing, spring 2016.